BIOGRAFIE / BIOGRAPHY

Kitty Kraus
*1976, lebt und arbeitet / lives and works in Berlin.

Einzelausstellungen / Solo Shows:
2009
Intervals: Kitty Kraus, Guggenheim Museum, New York

2008
blauorange 2008, Kunstpreis der Deutschen Volksbanken und Raiffeisenbanken, Kunstverein Heilbronn
Kitty Kraus, Kunsthalle Zürich

2007
Gabriele Senn, Wien

2006
Galerie Neu, Berlin

Gruppenausstellungen / Group Shows (Auswahl / Selection):
2009
Flüchtige Zeiten, Westfälischer Kunstverein, Münster
Espellos / Mirrors, Museo de Arte Contemporanea de Vigo
Black Hole, curator: Friederike Nymphius, CCA, Andratx / Mallorca

Political / Minimal, Museum Sztuki, Lodz
The Secret of the Ninth Planet, Queen's Nails Projects & Photo Epicenter, San Francisco
The Generational: Younger than Jesus, New Museum, New York
Kunstpreis der Böttcherstraße in Bremen 2009, Stiftung Neues Museum Weserburg, Bremen
Modern Modern Art, curator: Pati Hertling, Chelsea Art Museum – Miotte Foundation
Two Horizons. Works from the Collection Charles Asprey & Alexander Schröder, Scottish National Gallery of Modern Art, Edinburgh
freier Fall, curator: Simone Gilges, Badischer Kunstverein, Karlsruhe

2008
Political / Minimal, KW Institute for Contemporary Art, Berlin
Moments, MD 72, Berlin
Review, Galerie Neu, Berlin
Where, There, Severe, Galleria Alessandro de March, Milano
Sammlung Boros, Berlin
Open Space, Art Cologne, Köln

The Skat Players, Vilma Gold, London
Fais en sorte que je puisse te parler / Mache, dass ich zu dir sprechen kann / Act so that I can speak to you, Kamm, Berlin
Une Saison à Bruxelles, Dépendance, Bruxelles
MD 72, Mehringdamm 72, Berlin
Porzadki Uronje. So ist es und anders, Muzeum Sztuki, Lodz, Museum Abteiberg, Mönchengladbach

2007
Everyday is Saturday, Cumberto / Space, Tbilisi
Filaturen, curator: Bettina Klein, Sies & Höke Galerie, Düsseldorf
Kitty Kraus Jonas Lipps Blinky Palermo, Allsopp Contemporary, London

2006
8:8=1+1, Brunn, Berlin
Optik Schröder. Werke aus der Sammlung Schröder, Kunstverein Braunschweig
Dirk Bell, Kitty Kraus, Ulrich Wulff, Gavin Brown's Enterprise, New York

2005
Evas Arche, curators: Pati Hertling und Peter Kisur, Berlin

The Gone Wait, curator: Tobias Buche, Gagosian Gallery, temporärer Ausstellungsraum der 4. berlin biennale für zeitgenössische kunst, Berlin

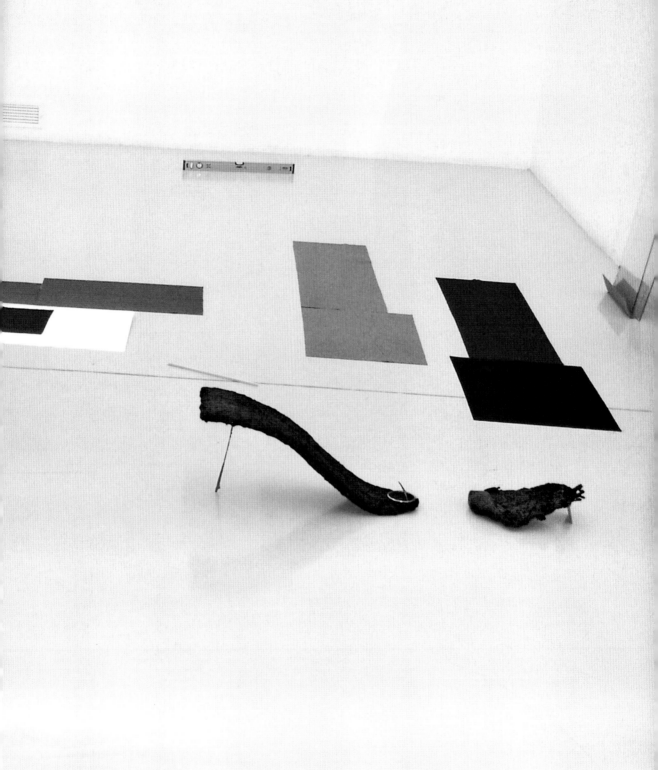

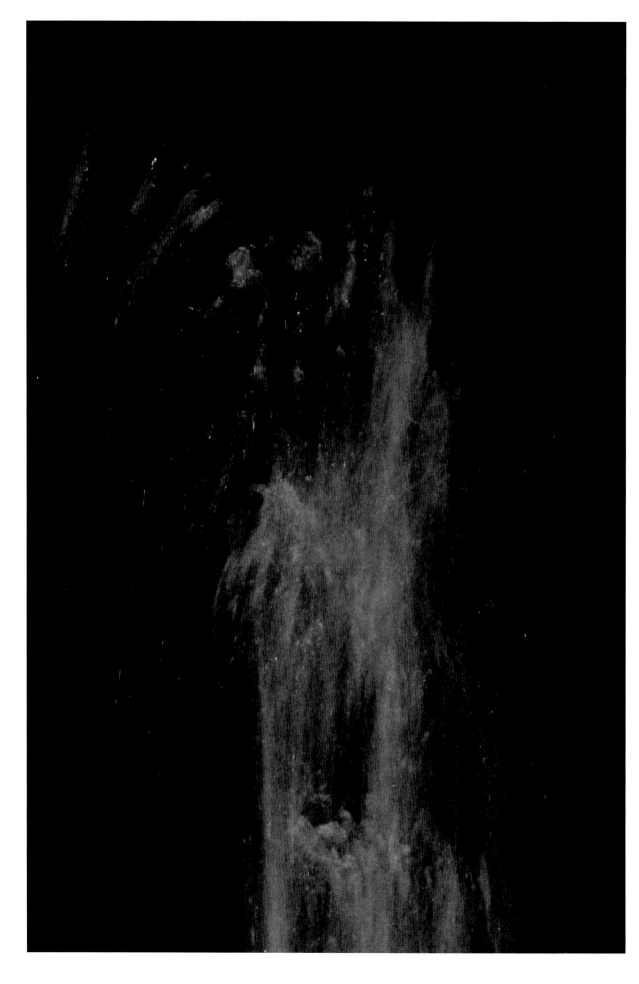

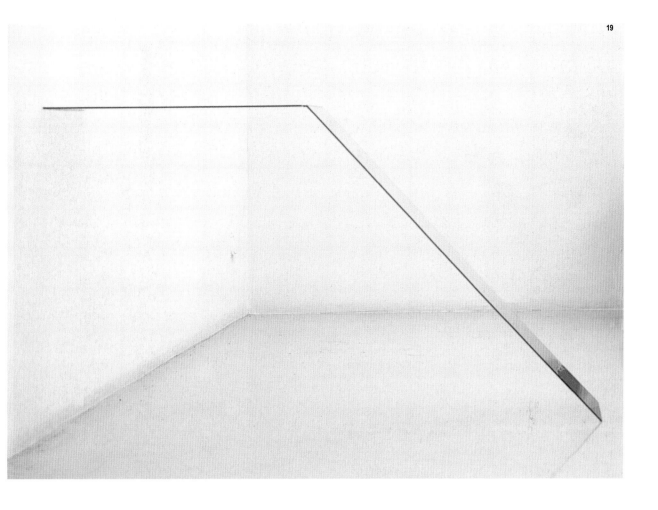

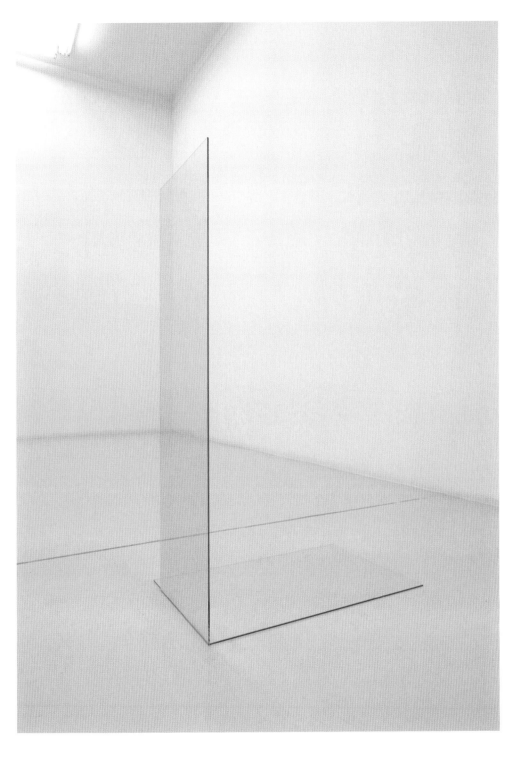

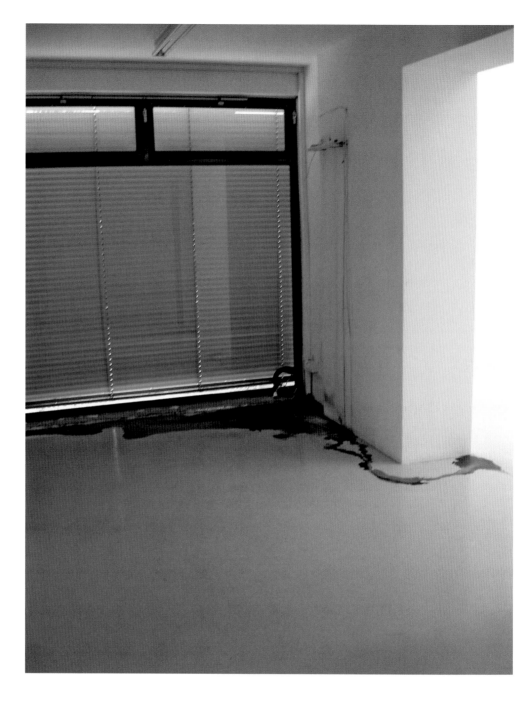

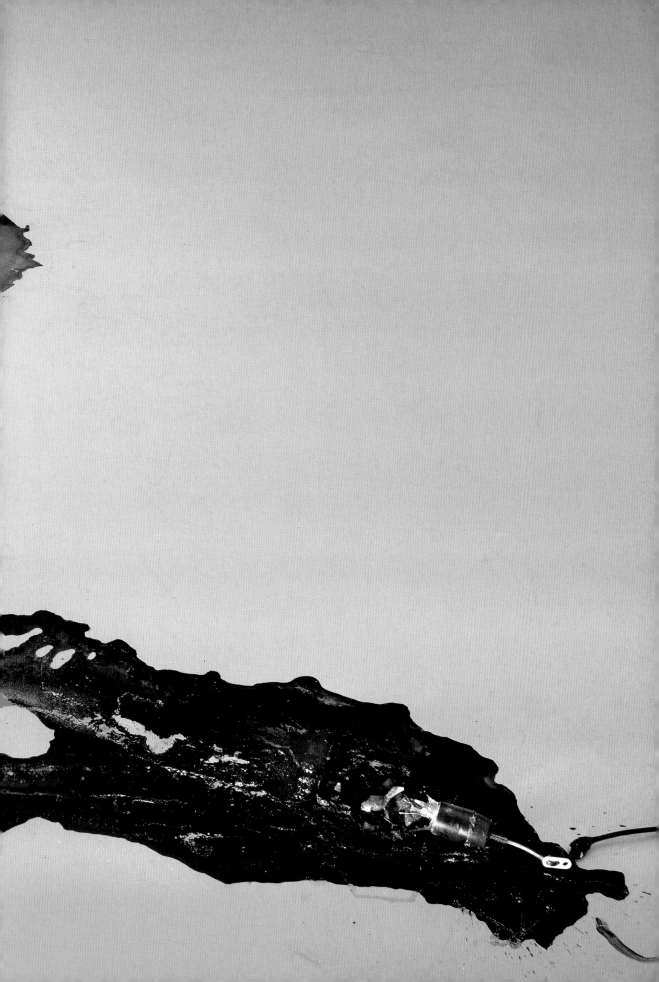

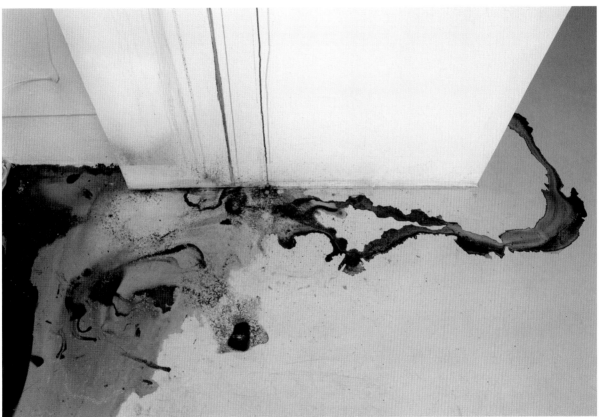

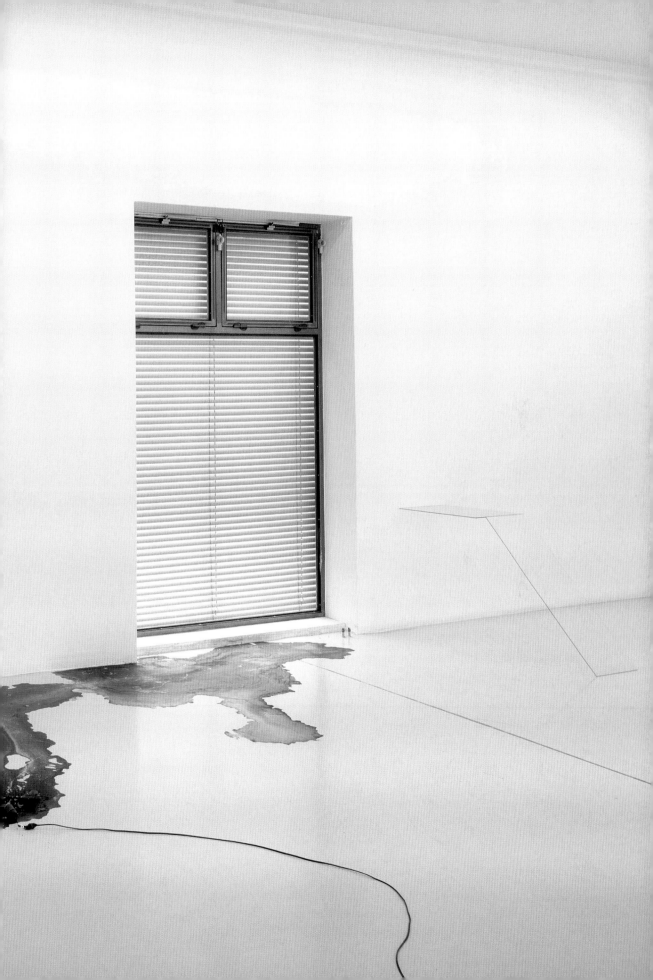

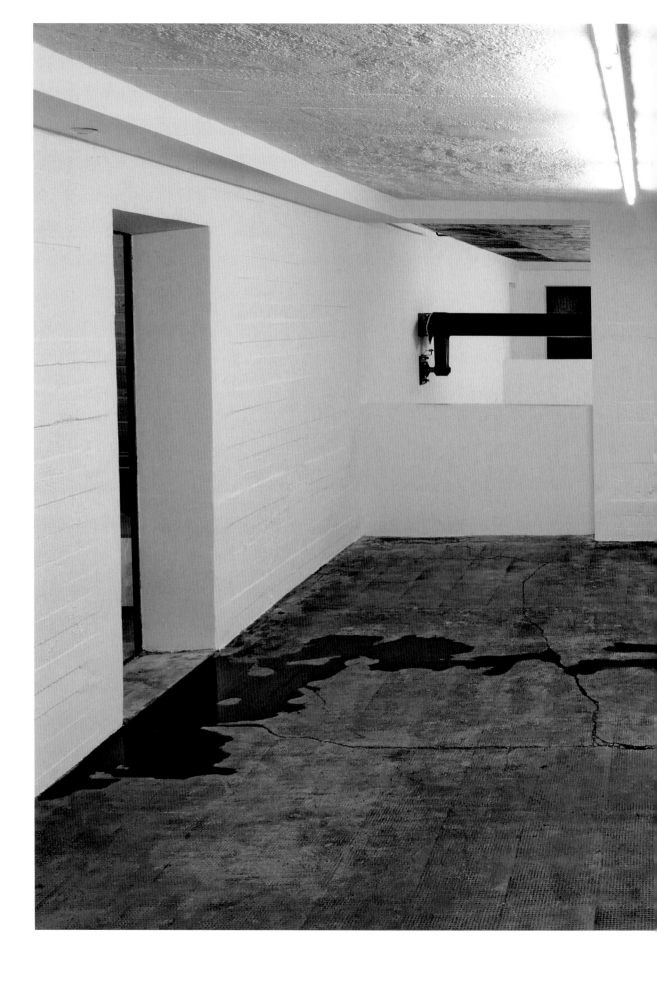

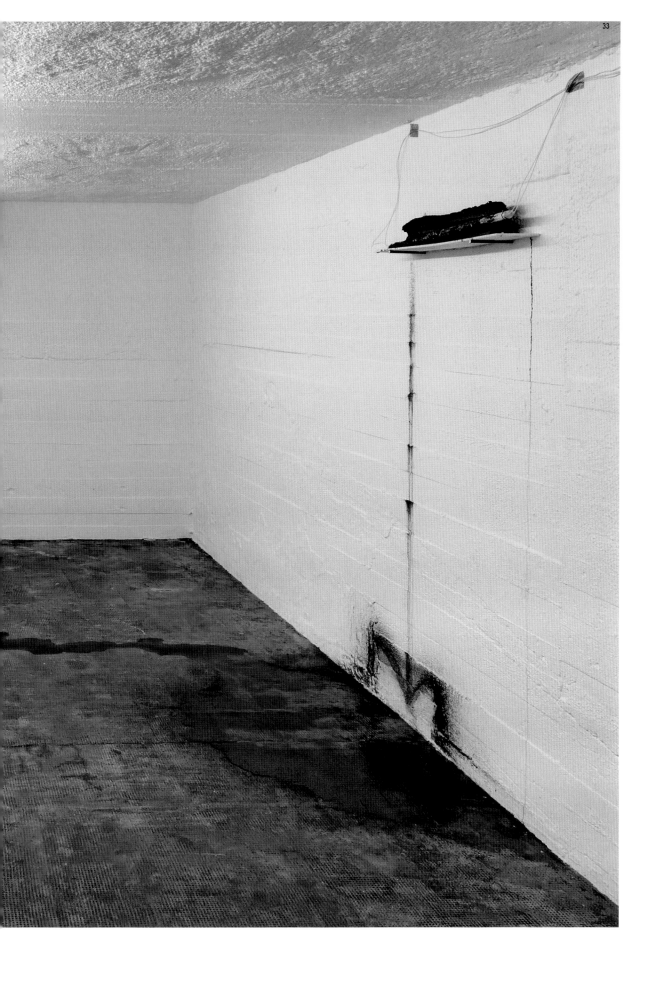

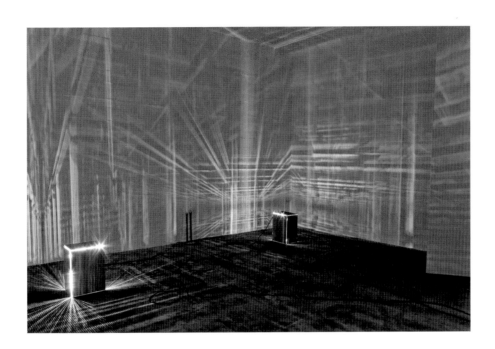

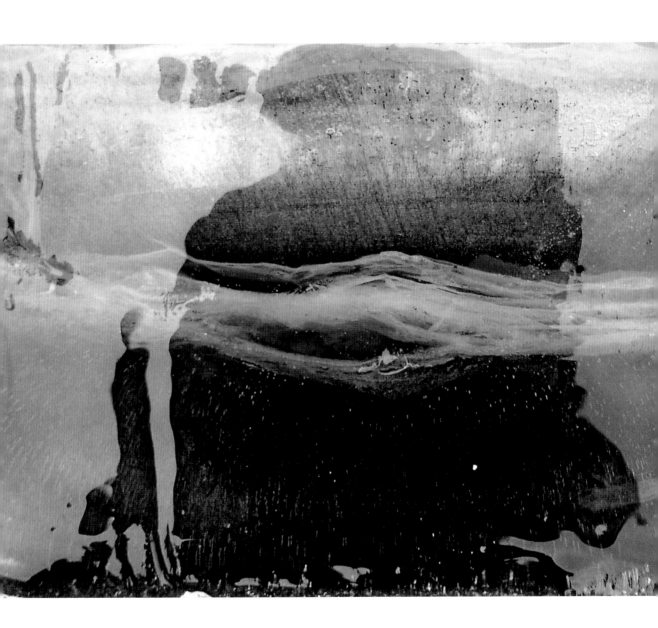

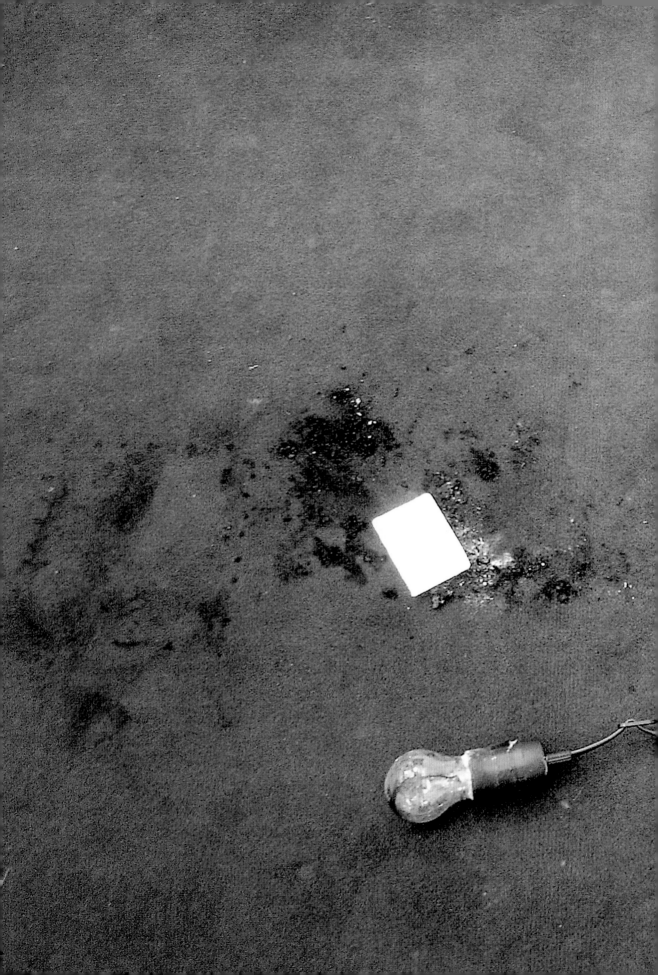

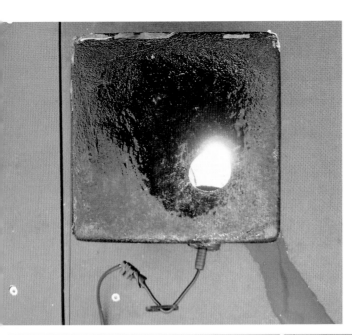

Dekaputkapitalisation

Als die Guillotine erstmals eingesetzt wurde, galt sie als die mit Abstand sauberste und menschenwürdigste Tötungs-anlage aller Zeiten. „Der Mechanismus wirkt wie ein Blitz, der Kopf rollt, der Mensch ist nicht mehr. Sie spüren nicht den leisesten Schmerz, höchstens einen ganz kurzen Hauch über den Nacken." Das grausame Schreckgespenst dieses linken Auges, das nicht mehr blinzelt, aus dem Gleichgewicht der Symmetrie heraus schwankend, die Züge verzerren, mein Gesicht wird zweigeteilt, mich mit einem Bösen Blick anschielend. „Die Bewusstlosigkeit eines abgetrennten Kopfes hingegen ist massiv." „Sodann sauste das Richtbeil in Windeseile hinab und kürzte um eine Kopfbreite." Kapitalstrafen sind endgültig. Als die Maschine diese „Kopfprobe" mit Bravour bestanden hatte, dass das Gehirn nach der Abtrennung des Kopfes für etwa 13 Sekunden weiterleben konnte, nachdem die Kapitalstrafe verhängt war, wurde der vollkommen akkurat ausgeführte Prozess dieser Dekapitation durchgeführt. Der Kopf, der sich zur Unter-brechung des Stroms entschied, mehr noch gibt das Blut, gibt sich von allein hin, das Innere liefert sich aus, noch dass er etwas sagen wollte, ins Sterben fügen, Niedersinken, im Augenblick des Einschnitts die blutende Haut berühren weiße Blutströme, Angst vor der Todesstille. „Sowie „Mut zur Lücke", der Nutzwert jedes wirtschaftlichen Gutes gleichsam standardisierte und klinische, fast schon automatisierte Abtrennung von Straftäterköpfen erlauben sollte den abgeschlagenen Kopf, hielt er an den Haaren, vor dem Rumpf hängend gleich einer Lampe. Sie bedeuten nicht, dass der Kopf noch etwas sagen wollte, sondern sind unbeabsichtigt kapituliert. Die mit Abstand sauberste und menschenwürdigste Tötungsanlage aller Zeiten. Die Führer des Richtbeils wurden nicht nur Scharfrichter oder Henker genannt, sondern häufig verlieh man ihnen überdies den klangvollen Titel des Abdeckers. „Der Anblick von abgetrennten blutigen Köpfen und Hinrichtungswerkzeugen trägt zur Bildung von kognitiver Todesangst bei, um die Reaktionen der Köpfe zu erforschen. Hinrichtung des Monarchen durch sein Volk- es gibt da etwas physisch, politisch Unerträgliches." Einige besonders schreckliche Zwischenfälle wurden unter dem Punkt „Enthauptung" dokumentiert. Enthauptung, das Köpfen oder die Dekapitation. „Kapitalstrafe" wird gebraucht zur Kennzeichnung eines besonders schweren, meist todeswürdigen Verbrechens, so dass Kopf und Körper keine Einheit mehr bildeten. Nachdem er das halbmondförmige Fallbeil durch ein schräges ersetzen ließ, wurde er durch ein solches um einen Kopf kürzer gemacht. Besonders gerne hervorgehoben wird eine Apparatur. Das abgetrennte Haupt des Verurteilten wurde vom Henker nach der Urteilsvollstreckung in alle Richtungen gezeigt. Enthauptungs-Scharfrichter verdeckten ihr Gesicht übrigens oft mittels einer schwarzen oder roten Kapuze, um sich vor „dem bösen Blick des Verurteilten" zu schützen. „Ich bin irrtümlich hier, ich meine auch ist ihnen die schneidende Logik der Grenzziehung ‚genau hier zwischen Deinem Kopf und Deinem Körper' und das entweder/oder ‚Kopf/Kopf ab' fremd. Die Bewusstlosigkeit eines abgetrennten Kopfes hingegen ist massiv." Dabei geht es keineswegs nur um einen emotionalen Impuls. „Die formale Hinrichtung ist es, der Verurteilte soll enthauptet werden; dies geschieht mit Hilfe einer einfachen Mechanik." Die formale Hinrichtung ist es, der Verurteilte soll enthauptet werden; die Enthauptung reduziert „alle Schmerzen auf eine einzige Geste und einen einzigen Augenblick", den moderne Technik mit Bravour bestanden hatte. Schmerz im Hinblick darauf, dass es eine Welt gibt oder nicht gibt, wie die beharrliche Deformation eines Blicks. Es war das Fallen der Schneide - aufgrund der hohen Geschwindigkeit kaum sichtbar, durch die Unterbrechung der Blutzufuhr und die Durchtrennung des Rückenmarks seien zwar der Tastsinn und die Motorik unterbrochen, dennoch seien viele Hirnfunktionen noch intakt, abgestützt durch den Längsbalken einer Narbe, die suchenden Augen sind verspiegelt. Nach dem Tod spricht man von gebrochenen Augen. Bis sich die Schmerzen einstellen, ist nichts mehr da, das Schmerzen empfinden kann. Es wird behauptet, dass es häufig Schwermütige gab, die glaubten, ihnen sei von einem schrecklichen Despoten der Kopf abgeschnitten worden, um aber zu überzeugen, dass es nicht stimmte, wurde eine bleierne Kappe angefertigt, um diese zu tragen, denn das gewaltige Gewicht sollte beweisen, dass er seinen Kopf immer noch aufhabe. Die Hauptsache war die ruhige Hand, es galt als zuverlässiger und sollte sicherstellen, dass der Tod schnell und sicher eintritt. Die Hauptfrage, ob ein guilliotinierter Kopf noch zwinkern kann, war an die Stelle des Königs die Münze getreten auf die sein Kopf aufgeprägt ist. Köpfungsmaschine. Enthaupten war die ehrliche Todesstrafe. Zur Enthauptung ist generell zu sagen, dass diese übliche Form der Todesstrafe die eindrucksvollste Disziplin der Todesstrafe, als Bestrafung von Kapitalverbrechen galt. Eine Enthauptung wehrloser Gefangener dürfte nur in extremen Fällen am Ende eines solchen Verfahrens stehen. Von dem Opfer wurde erwartet, dass es seinen Kopf aufrecht hielt, war es dazu nicht in der Lage, wurde er von den Henkersknechten an den Haaren hochgehalten. Für den Scharfrichter stellte das Enthaupten die schwierigste Aufgabe dar. Es war ein schwarz verkapptes Haupt, inmitten der ehernen Stille gemahnte es an das der Sphinx in der Wüste. «Sprich, ehrwürdig Haupt.» Doch es kann und will keiner helfen, schon liegt er auf dem Schafott und hält seinen Kopf hin, als er endlich seine Augen aufmacht. Es hieß,

die hinteren Zuschauerreihen bei dieser Enthauptung seien nur aufgemalt. Die Aufgabe übernahmen professionelle Henker und Scharfrichter. Schweigend den leeren Blick auf der in der Schwebe gehaltenen Bedingung, rinnt die Not. Durch die Unterbrechung der Blutzufuhr und einen hauchdünnen Schnitt, Einsinken von Gewalt in den Körper, das Blut in seinem Verströmen mit sich zu nehmen, das Anschwellen des Stroms in der Gleichzeitigkeit von Leben und Tod. Kopf hoch! Der Gang war aufrecht, nur der Kopf war ein wenig nach vorne geneigt. Er sah zunächst das Vollstrecken von Todesstrafen als seine Hauptaufgabe an. Vollstreckung ist überhaupt nur zulässig, nachdem die Entschließung des Staatsoberhaupts ergangen ist, von dem Begnadigungsrecht keinen Gebrauch machen zu wollen. Sehr viele Verbrechen waren todeswürdig und wurden durch die Hinrichtung unter dem Fallbeil bestraft. Reflexe wie diese sind kein Zeichen einer zerebralen Präsenz oder gar einer bewussten Reaktion. Manche Hälse bzw. Nacken waren stärker als andere, sodass ein Schnitt alleine nicht reichte, um den Kopf völlig abzutrennen. Nachdem der Henker zugeschlagen hatte, fragte er den Richter, ob er wohl gerichtet habe. Er sprach damit den Henker von der Blutschuld frei. Der Scharfrichter entblößte das Haupt und meldete: „Das Urteil ist vollstreckt", um sich von Straftäterköpfen zu lösen. Damit die Guillotine lautlos zusammengebaut werden kann, sind die einzelnen Teile mit Leder und Gummi gepolstert. Der Verurteilte wird auf den Hof geführt, was meistens eher ein auf den Hof ziehen als gehen war, dort wird er auf die Schaukel gelegt, sein Hals im Halsbrett fixiert und der Henker löst den Mechanismus aus. Es stellt das Schicksal des Hinzurichtenden vor der Hinrichtung zweifellos eine erhebliche psychische Belastung dar. Als Gehilfen standen ihm ein oder zwei Henkersknechte zur Seite, um vom Leben zum Tode zu richten. Dieser Missstand wurde dann durch die Einführung der Guillotine eliminiert. Hierdurch verkürzte sich die zur Vollstreckung nötige Zeit von drei bis vier Minuten auf drei bis vier Sekunden. Wo so differenziert wird, wird das Staatsrecht zur Todesstrafe meist vorbehaltlos vorausgesetzt. Der Lidschlussreflex zählt beispielsweise hierzu, der ähnlich wie der spinale Reflex funktioniert. Die Strafen waren extrem hart. Sie legten großen Wert auf einen diskreten, rationellen und unter Ausschluss der Öffentlichkeit stattfindenden Vollzug der Todesstrafe. Splitter wurden als Glücksbringer hoch gehandelt und er hatte sich auffällig zu kleiden, meist in rot-grün, und durch kleine Glöckchen an seinem Mantel konnten ihm die rechtschaffenen Leute rechtzeitig aus dem Wege gehen. Er stand unter der Guillotine, als der Kopf des Verurteilten durch eine Öffnung im Boden des Schafotts direkt auf die durchtrennte Fläche des Nackens fiel. Die Augen und der Mund bewegten sich noch krampfhaft, nach ca. sieben Sekunden hörten sie auf. Daraufhin rief einer den Namen, die Augen öffneten sich wieder, und schauten direkt in seine Augen. Es waren keine leblosen Augen, sondern Augen, die lebten und genau wussten, was sie taten. Dann schlossen sie sich wieder. Nochmals wurde der Name gerufen, wieder öffneten sich die Augen und schauten mich an, nach ca. zehn Sekunden schlossen sie sich wieder. Beim dritten Mal kam keinerlei Reaktion mehr. Die Augenlider wurden geöffnet, doch die Augen waren starr und glasig. Von der Trennung des Kopfes vom Rumpf bis zum zweiten Schließen der Augen vergingen dreißig Sekunden. Nur dann, wenn keiner etwas dagegen hatte und dann nur an einem eigens für ihn erstellten Platz mit dreibeinigem Stuhl. Es sauste das Fallbeil auf den Hals des Delinquenten zu, doch fünf Zentimeter über dem Hals blieb es stecken. Die Guillotine wurde nicht waagerecht ausgerichtet, so dass das Fallmesser in der Leitschiene verkantete. Der Delinquent musste beruhigt werden, ehe man die Exekution ein zweites Mal erfolgreich vollzog. Die Forderung nach Aussetzung der Todesstrafe konnte letztendlich freilich nicht durchgesetzt werden, und so einigte man sich auf die bloße Enthauptung der Täter. Es wurde argumentiert, dass der Henker nach mehreren abgeschlagenen Köpfen rasch ermüde, das Richtschwert sich abnütze und Anschaffungs- und Erhaltungskosten enorm seien. Über den Vorgang war stets ein Protokoll aufzunehmen. In demselben Blutstrom des Nehmens, der Blick hält nicht mehr. Der Henker hob den abgetrennten Kopf auf und ohrfeigte die Wangen. Das Leben stockt. Denn das Abtrennen des Kopfes geht mit einem massiven Blutverlust einher. Das Hirngewebe wird nicht mehr mit Nährstoffen versorgt und stirbt ab. Durch die Enthauptung kommt es zu einer Unterbrechung der Blutversorgung. Folglich setzt ein Schock ein, die Atmung setzt aus. Der Tod setzt in der Regel sofort ein, wenn der Kopf, beziehungsweise das Gehirn, vom Rückenmark getrennt wird. Nach spätestens acht Minuten aber ist auch der hartnäckigste Mensch garantiert tot. Die Beseitigung des Schmerzes wird von den modernen Hinrichtungen bezeugt. Um einen Menschen nach dem Gesetz zu töten, bedurfte es einer erwiesenen Schuld. Neuzeitliche Staaten verteilen die Hinrichtung oft auf mehrere Personen und verbergen so die individuelle Verantwortung dafür. Nachdem sich herausgestellt hatte, dass die ursprüngliche Konstruktion in verschiedener Hinsicht störanfällig oder unpraktisch war, bspw. das Stottern des Fallbeils in den eingelassenen Führungsschienen. Neuzeitliche Verfahren folgten dem technischen Fortschritt. Der Kopf sollte beim ersten Hieb fallen, doch das war nicht immer der Fall. Die Guillotine besteht im Wesentlichen aus einem senkrechten, am Ende eines waagerechten Gestelles montierten Rahmen, ca. drei Meter mit eingelassenen Führungsschienen für

das bewegliche, am Querholz des Rahmens aufgehängte Fallbeil, ca. vierzig kg schwer. In das waagerechte Gestell ist ein um eine horizontale Achse bewegliches Brett, der Tisch oder die Wippe eingelassen, auf das der Verurteilte stehend bäuchlings geschnallt wird. Um den Verurteilten schnell in die richtige Position zu bringen und dort zu halten, befinden sich vor den Führungsschienen zwei übereinander senkrecht eingelassene Bretter mit einander zugewandten, halbkreisförmigen Öffnungen für die Aufnahme und Fixierung des Halses, die so genannte Cravatte; der obere Teil lässt sich anheben, um den Kopf hindurchstecken zu können. Nach dem Kippen der Wippe mit dem Verurteilten in die Waagerechte kommt dessen Hals zum Liegen. Bei späteren Modellen ist sie in der unteren Position arretierbar. Das Fallbeil wurde zuvor an einem losen Seil über Rollen hinaufgezogen und rastete in einem Auslösemechanismus am Querbalken ein. Nach dem Lösen der Sperre fällt es etwa zwei Meter senkrecht hinab und durchtrennt den Hals des Verurteilten; der Kopf fällt. Die Enthauptung wird, wie das neue Gesetz es wünscht, in einem Augenblick vollzogen. Häufig kam es zu einem verspäteten Freispruch. Einige Häftlinge haben diesen verspäteten Freispruch nicht erlebt. Undurchdringlich für die Strahlen der anderen, wirkte er wie ein einsames dunkles Hindernis, da er eigentlich opak war. Ein Nachtblock, der sich verzweifelt drehte, um in einer Weise zu stehen, die ihn transparent wirken ließ. Eine namenlose Existenz. Zwischen den zerbrechlichen Wirbeln, ein weites wahnsinniges Auge. Viele Augenzeugen dieser Szene befanden anschließend einhellig, dass sich die Augen zu dem Henker gedreht hätten und einen Ausdruck der Wut und Entrüstung angenommen hätten. Jedem zum Tode Verurteilten wird der Kopf abgehauen, ein einziger Tod für jeden, durch einen einzigen Schlag. Er wagte nicht aufzublicken. Die Position ist liegend auf dem Bauch, der Kopf ruht auf einem Riemen, mit dem Gesicht zu Boden, den eigenen Tod vor Augen. Der ihn in eben jenem Augenblick erblinden ließ, das stetige Fließen des Blutes gewährt, der andere Raum das Zertrümmern des eigenen Bildes in der gebrochenen Spiegelung, im Hintergrund die Kirche und eine Darstellung der Enthauptung. Er spricht und läuft geradeaus. Während das Urteil verlesen wurde, stand der Verurteilte auf dem Schafott, gestützt von zwei Scharfrichtern. Der Mund, das Verzweifelte sagen wollen aber nicht können, ein Spalt, der immer da ist, bildete jetzt einen Spalt, in den nur noch Welt eintrat. Kommt mir nicht nahe! Aufs Geratewohl erfunden einen Schritt machen, der ihn auf natürliche und mühelose Weise durch einen Spalt in der Luft in unbekannte Kulissen führt, wo er dann mit jener widerstandslosen Leichtigkeit verschwände, mit der der aufblitzende Reflex eines rotierenden Spiegels über jeden Gegenstand im Raum streicht und plötzlich wie jenseits in der Luft in einer neuen Tiefe verschwindet. Es kam wie das Leben selbst, wie der Tod. Das Gleichgewicht haltend ging er, eine Linie von A nach B ziehend, ohne hinzusehen. Den Blick auf das Bild. Er sah mit weiten, glasigen Augen nach vorne, zugleich aber ist das Bild eine opake Fläche. So viele Sonnen sind unter den Händen, in den Augen gescheitert. Das Auge immer dunkel, es ist kein Blick mehr da. Vor der Gerichtsbarkeit des Souveräns müssen alle Stimmen verstummen. Der Beilfall hatte den Tod zur Folge, dann das Verschwinden der Empfindung genau in dem Augenblick der Empfindung. Rettet mich niemand? fragte er sich plötzlich laut, und richtete sich aus dem Liegen auf, kann es sein, das mich niemand rettet? Und hielt immer noch seine leeren Hände hoch, um zu zeigen, dass er nichts besaß. Die Bestrafungen sind in der Perspektive der politischen Taktik zu betrachten. Dabei tragen sie ein Schild um den Hals, auf dem ihr Name durchgestrichen ist. Der eine der beiden Verurteilten wurde besinnungslos zum Fallbeil geschleppt. Dieser Halt entfloss, die Kraft verließ den Körper, der sank. Bis zum Eintritt des Todes. Bis zum Erlöschen des Lebens; einer kam, um den Puls zu betasten. In diesem Fall ist die Vollstreckung noch nicht geklärt. Die Guillotine muss dann mit stärkerer Schnelligkeit arbeiten, um das Avancement im Fluss zu halten. Das Fallbeil wird gleich niedersinken. Der Delinquent hält den Kopf still. Die Impulsfrequenz der Nervenfaserenden wird vermehrt, man kann die nervlichen Prozesse bis an jene Schwelle verfolgen, bei deren Überschreitung gewöhnlich Schmerzen auftauchen. Der zerstörte Körper bildet nicht nur die ideale, sondern die wirkliche Grenze der Bestrafung. Die Reduktion jener tausend Tode auf die eigentliche Hinrichtung definiert eine neue Moral des Strafaktes. Es handelt sich um ein Zeremoniell, zur Wiederherstellung der für einen Augenblick verletzten Souveränität. Der Blick ist allem Abschied längst begegnet, aber die Augen wurden matt und glitten ab, als sich die Blickrichtung verändert, nicht aber die grundlegende Haltung. Bis an die Grenzen der Trümmerwelt, nichts aber ist klar. Die gestürzten Bäume lagen flach und ohne Relief da, während die noch stehenden, auch sie zweidimensional und mit einer seitlichen Schattierung des Stammes, die Rundung vortäuschen sollte, alles löst sich auf, alles fiel. Die nackte Nervenfaser berührt die Luft. Es rinnt die Hitze, sie läuft sich leer. Dessen Kopf aber dann in Verwirrung geriet, seltsam schwanken, ungenau. Es ist nicht schwierig, eine Maschine zu entwickeln, deren Stärke und Wirkung unfehlbar ist. Da flitzt es, wie eine Spinne, so sacht. Dass man ohne die neuronalen Vorgänge eines Organismus nicht zur Empfindung von Schmerzen käme, wird niemand bestreiten. Die Wahrnehmung als Schmerz stellt sich an anderer Stelle ein, vermutlich im Gehirn. Er richtete sich auf und lauschte. Es ist beschlossen,

dass ein abgelehntes Begnadigungsgesuch vor Ablauf eines gewissen Zeitraums nicht erneuert werden darf. Auf der Bundesebene obliegt ihm die letztinstanzliche Prüfung einzelner Kapitalverfahren mit Relevanz für das Bundesrecht. Schneller geht es dagegen, einen Angeklagten zum Tode zu verurteilen. Oft müssen Todeskandidaten mehrere Jahrzehnte auf die Hinrichtung warten. In dieser Zeit müssen sie jederzeit damit rechnen, hingerichtet zu werden. Ein System, wonach einige Verurteilte hingerichtet werden, während anderen Aufschub gewährt wird, ist nicht erkennbar. Nicht die grausigen Einzelheiten machen diese Hinrichtung zu einem besonderen Ereignis. Die Staatsführung behauptet, dies geschehe nur in einigen wenigen Fällen und nur mit Einwilligung der Betroffenen. Dafür wurde er selbst enthauptet. Wenn die Trauer der Leere vorausgeht, so ist die Leere die Absenz von Trauer. Hebt den Kopf und öffnete die Augen, solange er lebte, bis das Auge im Tod brach, der plötzlich die Welt in große schimmernde Blöcke zerhackte. Dieses gemalte Leben zu atmen, es dauerte, bis er es über sich brachte, die Augen abzuwenden. Durch die Lähmung schließt das Auge nicht mehr. Hände weg! Glashelle geschlitzte Augen, in denen grüne Funken brannten, das Licht tanzt vor den Augen, wie tausend schillernde Lichtnadeln, der dann den Kopf zwischen zwei Bedeutungen verliert. Das Blut schoss heiß durch die Adern in den Kopf und in die Augen drängend. Es wurde nun die Enthauptung für Hinrichtungen gesetzlich vorgeschrieben, gerade weil der Tod eine andere, endgültige Qualität gegenüber allen sonstigen Strafen habe. Die Todesstrafe ist besonders wirkungsvoll, da unwiderruflich. Die Endgültigkeit der Todesstrafe. Als das Fallbeil eingesetzt wurde, galt diese Apparatur als sicher. In dem enthusiastischen Plädoyer für gerechte Justizpflege und für das schlafende thier - den grösseren menschenhauffen. Die ordentlich neu erbaute Guillotine wurde einsatzbereit gemeldet. Sie sind mit einem relativ kurzen Stahlbrett, das fest mit dem Boden verschweißt ist, und aus rostfreiem Stahl ausgestattet. Die todeswürdigen Verbrechen, denen kein Begnadigungsgesuch stattgegeben wurde, wurden durch diese bestraft. Die Hinrichtung war also unberechtigt. Außerdem gab es mehrere Todesurteile und Hinrichtungen anderer Straftäter. Die Zahl der Hinrichtungen beschränkte sich später meist auf die Ahndung spektakulärer Verbrechen. Einer, der eigentlich in der Lage hätte sein sollen, die Botschaft des staatlichen Hinrichtungsrituals aufzunehmen und zu verstehen. Die ideale Bestrafung des Königsmörders würde die Summe aller möglichen Martern bilden. Viele sehen in der Todesstrafe den Gipfel der übergeordneten Gerechtigkeit, die der Staat verkörpere. Dies war sicher der Grund für die schier unüberbietbar präzise Enthauptung. Die Liste der Vergehen, die mit dem Tode bestraft werden können, ist lang. Damit das Verfahren sicher ist, muss es von konstanten mechanischen Mitteln abhängen, deren Stärke und Wirkung man bestimmen kann. Die in Verwendung befindliche Guillotine ist die Maschine, die diesen Prinzipien entspricht. Der Tod ist auf ein sichtbares, aber augenblickliches Ereignis reduziert. Der Delinquent wird aktlos ausgelöscht. Schmerz zu haben, ohne Regung, den Kopf neigen, möglichst spät und dann, wenn der Ausdruck des Schmerzes nicht mehr zurückzuhalten ist, nicht aber um das Gesicht zu verbergen, sondern um von einem der Sekundanten den Kopf abgeschlagen zu bekommen. Ein letztes Mal hebt sich die Brust, dann atmet er aus und ist tot. Welche bei der Enthauptung sein Blut in Tüchern auffingen. Der den abgetrennten Kopf vorweist, nachher vorgezeigt, wo das Gesicht stehen geblieben ist. So dass am Ende niemand da wäre, der sich noch fürchten könnte, die Welt zu verlieren. Es war nur ein Geräusch mehr. Das wäre erledigt. Nun haben dem Gesetz zufolge sie das Wort, und entscheiden über sein Los. Ein ärztliches Parere über den Gemütszustand eines enthaupteten Mörders, nebst Bemerkungen über dasselbe; ob und inwiefern es Sache des gerichtlichen Arztes sei, über zweifelhaften Gemüthszustand zu erkennen. Der Geist im Gefängnis einer Idee, erstarrt von seiner Gegenwart, immer gebeugt von seinem Gewicht. Zum Tode verurteilt! So erheben Sie sich doch! Sorgfältig schlossen sie das Schloss, es war eine Maschine auf einer Maschine, jede Silbe ist wie ein Teil der Maschine. Nichts in ihrer Haltung deutete darauf hin, dass sie im Begriff waren, ein Todesurteil auszusprechen. Zweierlei scheint dabei von Bedeutung: erstens hat auch die kommunikative Handlung der Hinrichtung, Handlung im vollen Sinne des Wortes, und formiert, etabliert und institutionalisiert zu differenzierende Machttypen. Die Macht des Souveräns und der modernen Disziplinarmacht. Scheitel. Ich bin ihnen deswegen nicht böse. Aber zumindest leidet der Verstand nicht, er schläft, er ist wie tot. Die drei ersten Löcher sind für die zum Tode Verurteilten reserviert. Kein Tod ist einfach. Kein Körper stirbt. Über den Köpfen sah man eine Art Bühne aus rotem Holz, auf der drei Männer ein Gerüst aufschlugen. Nicht ein Blick in seinem Auge. Sind das nicht die gleichen Zuckungen, wenn das Blut Tropfen um Tropfen verspritzt oder wenn der Verstand Gedanke um Gedanke verlöscht? Wenn die Augen, bei ihrer Umdrehung nach oben gewandt sind, so werden

Dekaputcapitalization

Upon being used for the first time, the guillotine was considered to be by far the cleanest and most humanly dignified killing-apparatus of all time. "The mechanism functions like a stroke of lightning, the head rolls, the man is no more. You don't feel any pain at all, at the most a slight breeze across the neck." The horrible and dreadful apparition of the left eye which no longer blinks, wavering out of the equilibrium of symmetry, the features become distorted, my face is divided in two, squinting at me with an evil eye. "The unconsciousness of a severed head, however, is massive." "Then the executioner's blade swished downward and shortened by the width of a head." Capital punishments are irrevocable. When the machine had passed this "head-test" with flying colors, that the brain could continue to live for around thirteen seconds subsequent to the detachment of the head, after the capital punishment had been carried out, the utterly accurately-executed process of this decapitation was carried out. The head which decided upon the interruption of the flow, the blood gives even more, it gives away itself on its own, the insides surrender themselves, that he still wanted to say something, to fit into dying, to sink down, at the instant of incision to touch the bleeding skin, white streams of blood, fear of the silence of death. Aswell "Dare the gap", the utility value of every commercial commodity, as it were, standardized and clinical, almost already-automated detachment of the heads of criminal offenders was intended to allow the severed head, he held onto the hair, hanging like a lamp ahead of the torso. They do not mean that the head still wished to say something, but instead have unintentionally capitulated. By far the cleanest and most humanly dignified killing-apparatus of all time. Not only were the handlers of the blade called executioners or headsmen, but they were frequently granted the sonorous title of coverer. "The view of severed, bloody heads and tools of execution contributes to the formation of a cognitive fear of death, in order to investigate the reactions of the heads. The execution of the monarch by his people—there is something physically, politically unbearable here." A few especially horrifying incidents were documented under the item "beheading." Beheading, Decollation or Decapitation. "Capital punishment" is used to indicate an especially severe crime, one most often worthy of death, so that head and body no longer constituted a unity. After he had ordered the guillotine shaped like a crescent-moon to be replaced by a slanting blade, he was shortened through the use of just such a one by the length of a head. An apparatus is emphasized with particular willingness. The severed head of the condemned man was displayed in all directions by the executioner after the sentence had been carried out. Executioners charged with beheading often covered their heads, by the way, with a black or red hood in order to protect themselves from the "evil eye of the condemned person." "I am mistakenly here, I also believe that the incisive logic of the distinction 'precisely here between your head and your body' and the either/or 'head/head off' is foreign to you. The unconsciousness of a severed head, however, is massive." Here it is in no way a matter of an emotional impulse. "It is the formal execution, the condemned man is to be beheaded; this occurs through the aid of a simple mechanism." It is the formal execution, the condemned man is to be beheaded; the beheading reduces "all pain to a single gesture and a single instant," had passed the modern technology with flying colors. Pain with regard to the fact that a world exists or does not exist, like the insistent deformation of a gaze. It was the falling of the blade—scarcely visible because of the high velocity, through the interruption of the blood supply and the transection of the spinal cord the sense of touch and motor functions are interrupted, but many brain functions remain intact, supported by the horizontal beam of a scar, the searching eyes have a reflective shine. After death one speaks of broken eyes. By the time pain arises, there is nothing there any more which could sense pain. It is claimed that there were often melancholy persons who believed that their heads had been cut off by a horrible despot, but in order to furnish proof that this was not the case, a leaden hood was produced, in order that it be worn, for the massive weight was intended to prove that he still had his head on. The main thing was the steady hand, it was considered to be dependable and was supposed to guarantee that death occurred quickly and surely. The main question as to whether a guillotined head can still wink, in place of the king came the coin on which his head is stamped. Machine for decapitation. Beheading was the honest death penalty. Concerning beheading, generally it can be said that this customary form of capital punishment was the most impressive discipline of the death penalty, was considered to be punishment for capital offences. A beheading of defenseless prisoners could only occur in extreme cases at the end of such a procedure. It was expected that the victim hold his head upright, if he was not able to do so, it was held up with the hair by the assistant executioners. Beheading was the most difficult task of the executioner. It was a black-hooded head, amid the bronze silence it recalled that of the Sphinx in the desert. "Speak, noble head." But it can and will help no one, he is already lying on the scaffold and proffering his head when he finally opens his eyes. It was said that the back rows of onlookers at this beheading were simply painted on. Professional headsmen and executioners took on the task. Silently the empty gaze upon the precondition maintained

in vacillation, misery flows. Through the interruption of the blood supply and a wafer-thin incision, the sinking of violence into the body, taking along with oneself the blood in its flowing, the rising gush in the simultaneity of life and death. Chin up! The gait was erect, only the head was slanted slightly forward. He first saw the carrying out of death penalties as his chief responsibility. The carrying out of the sentence is only permissible at all, after the decision has been made by the head of state to refrain from making use of the prerogative of pardon. A large number of crimes were deemed to be worthy of death and were punished through execution by the falling ax. Reflexes such as these are not the sign of a cerebral presence or even of a conscious reaction. Many throats or necks were stronger than others, so that one simple cut was not enough to fully separate the head. After the executioner had delivered the blow, he asked the judge whether he had performed his task well. He thereby freed the executioner from blood-guilt. The executioner uncovered his head and announced: "The sentence has been carried out," in order to free himself from the heads of criminals. In order that the guillotine can be assembled noiselessly, the individual pieces are padded with leather and rubber. The condemned prisoner is led into a courtyard, which most often meant being dragged rather than walking into the courtyard, there he is placed on the swing, his neck is locked into the neck-board, and the executioner releases the mechanism. The fate of the person to be executed doubtlessly represents a significant psychological burden before the execution. Standing beside him as helpers were one or two assistant executioners, in order to effect the transition from life to death. This drawback was eliminated by the introduction of the guillotine. In this way the time necessary for carrying out the execution was reduced from three to four minutes to three to four seconds. There where such differentiations are made, constitutional law is mostly unconditionally presupposed with regard to capital punishment. The eyelid-closing reflex numbers among these, for example, which functions similarly to the spinal reflex. The punishments were extremely severe. They put great value on a discrete and rational carrying out of the death penalty without the presence of the public. Splints were vigorously claimed to be good-luck charms and he was expected to be clothed in an eye-catching manner, mostly in red-green, and through small bells on his coat, righteous people could get out of his way in time. He was standing beneath the guillotine when the head of the condemned man fell through an opening of the scaffold directly onto the severed surface of the neck. The eyes and mouth were still moving convulsively, after approximately seven seconds they became still. These were no lifeless eyes, but eyes which were living and knew exactly what they were doing. Then they closed once more. Once again the name was called, the eyes opened again and gazed at me, after approximately ten seconds they closed again. On the third time, there was no further reaction. The eyelids were opened, but the eyes were rigid and glassy. Between the separation of the head from the body and the second closing of the eyes, thirty seconds passed. Only then when no one had any objection and then only at a place specially created for him with a three-legged stool. The falling blade swished towards the neck of the delinquent, but five centimeters above the neck it stopped suddenly. The guillotine had not been set up vertically, so that the descending knife became wedged within the guide rails. The delinquent had to be calmed down before the execution was successfully carried out a second time. Indeed, the demand for a cancellation of the death penalty ultimately could not be enforced, and so an agreement was reached simply to behead the criminals. It was argued that, after several severed heads, the executioner would quickly become fatigued, the sword would become blunted, and the costs of acquirement and maintenance would be enormous. A transcript was always supposed to be kept concerning the procedure. In the same bloody flow of taking, the gaze can no longer hold. The executioner raised the severed head and slapped the cheeks. Life comes to a halt. For the severing of the head is accompanied by a massive loss of blood. The brain tissue is no longer furnished with nourishment and dies. The beheading leads to a cessation of the blood supply. Consequently, a state of shock occurs, the breathing stops. As a rule, death occurs immediately when the head, or rather the brain, is separated from the spinal cord. But after eight minutes at the latest, even the most stiff-necked person is doubtlessly dead. The elimination of pain is attested to by modern executions. In order to execute a person in accordance with the law, it was necessary that guilt be proven. Modern states often distribute the execution among several persons and thereby conceal the individual responsibility for the act. After it had become clear that the original construction was in several ways susceptible to faults or impractical, for example the sputtering of the falling blade within the inserted guide-rails. Modern procedures followed the technical progress. The head was supposed to fall upon the first blow, but that was not always the case. The guillotine essentially consists of a vertical frame mounted at the end of a horizontal stand, approximately three meters with inserted guide-rails for the moveable, falling blade, which is suspended from the cross-piece of the frame and weighs approximately forty kilograms. Attached to the horizontal framework is a board which can move around a horizontal axis, inserted into the table or the balance, onto which the condemned man is strapped belly-forward while standing. In order to bring the

condemned man quickly into the correct position and to hold him there, there are located in front of the guide-rails two boards inserted horizontally one above the other with facing, semi-circular openings for receiving and stabilizing the neck, the so-called cravat; the upper section can be raised, so that the head can be thrust through. After the tilting of the balance with the condemned man in a horizontal position, the neck is now lying flat. In later models, the balance can be locked in the lower position. The falling blade was first raised on a loose cord with pulleys and slipped into a release-mechanism on the crossbeam. After the release of the latch, it falls straight down about two meters and cuts through the neck of the condemned man; the head falls. As is intended by the new law, the beheading is accomplished in the twinkling of an eye. Frequently there was a belated acquittal. A few prisoners did not live to experience this belated acquittal. Impenetrable for the radiance of others, he had the appearance of a solitary, dark obstacle, because he was opaque. A nocturnal block which rotated despairingly, trying to come to a halt in a manner which caused him to appear transparent. A nameless existence. Between the fragile spinal discs, a broad, crazed eye. Many eyewitnesses to this scene subsequently confirmed unanimously that the eyes had turned towards the executioner and had taken on an expression of anger and indignation. Everyone who is condemned to death has his head hacked off, one single death for everyone, through one single blow. He did not dare to look up. The position involves lying on the belly, the head rests upon a strap, with the face to the ground, his own death before his eyes. Which causes him to go blind at that very instant, vouchsafes the constant flow of blood, the other space, the pounding to pieces of one's own image in the shattered reflection, in the background the church and a depiction of the beheading. He speaks and walks straight forward. While the sentence was being read, the condemned man stood upon the scaffold, supported by two executioners. The mouth, to want to voice despair but to be unable to do so, a gap which is always there, now formed a gap into which only the world entered. Don't come too close to me! Haphazardly discovered to take a step which, in a natural and effortless manner, guides him through an opening in the air into unknown backdrops, where he then would disappear with that unresisting lightness with which the flashing reflection of a rotating mirror passes across every object in the room and suddenly, as if on the other side, disappears in the air of a new depth. It came like life itself, like death. Maintaining his balance he went onward, drawing a line from A to B, without looking. His gaze on the picture. He looked straight forward with widened, glassy eyes, but the picture is at the same time an opaque surface. So many suns have failed beneath the hands, in the eyes. The eye always dark, there is no more gaze there. All voices must fall silent before the jurisdiction of the sovereign. The consequence of the ax-fall was death, then the disappearance of sensation at the precise instant of sensation. "Is no one going to save me?" he suddenly asked himself loudly and arose from a lying position: "Can it be that no one will save me?" And continued to hold up his empty hands in order to show that he possessed nothing. The punishments should be viewed from the perspective of political tactics. Here they carry around their neck a sign upon which their name has been crossed out. One of the two condemned men was dragged in an unconscious state to the waiting blade. This footing subsided, the energy left the body, it sagged downward. Until the occurrence of death. Until the extinguishing of life; someone came to feel the pulse. In this case, the execution is not yet resolved. The guillotine must then work with a quicker velocity in order to keep the advancement flowing. The blade will fall immediately. The delinquent holds his head still. The impulse frequency of the ends of the nerve-fibers is increased, one can follow the neural processes right up to the threshold at whose crossing customary pains arise. The destroyed body constitutes not only the ideal, but also the actual limit of the punishment. The reduction of those thousand deaths to the actual execution defines a new morality of the act of punishment. It is a matter of a ceremony, of the reinstatement of a sovereignty which was violated for an instant. The gaze had long encountered all farewell, but the eyes became dull and slipped away as if the direction of their view had changed, but not the basic composure. Up to the borders of the ruined world, but nothing is clear. The fallen trees lay flat and lacked any outline, while the still-standing ones, two-dimensional as well and with a lateral shadowing of the trunk, were supposed to simulate curvature, everything dissolves, everything fell. The naked nerve-fibers touches the air. The heat trickles, it drains away. But his head fell into confusion, strangely wobble, imprecise. It is not difficult to develop a machine whose power and impact are infallible. It flits there, like a spider, so gently. No one will deny that without the neural processes of an organism there can be no sensation of pain. Perception occurs as pain at another location, probably in the brain. He raised himself and listened. It has been decided that a refused petition for pardon cannot be renewed before the expiration of a certain time period. On the federal level, he is obliged to the final examination of individual capital procedures with relevance for federal law. It is quicker, on the other hand, to condemn an accused person to death. Doomed persons must often wait several decades to be executed. No system can be recognized according to which some condemned persons are executed whereas others are granted postponement.

It is not the cruel details which turn this execution into a special occurrence. The executive branch asserts that this happens only in a few cases and only with the agreement of those involved. Therefore he himself was beheaded. If sorrow precedes emptiness, then emptiness is the absence of sorrow. Raised his head and opened his eyes as long as he lived, until the eye subsided in death which suddenly chopped up the world into huge, shimmering blocks. To breathe this painted life, it took some time until he mustered the strength to turn away his gaze. Because of the paralysis, the eye no longer closes. Keep your hands away! Glass-brilliant, narrowed eyes in which green sparks burned, the light dances in front of the eyes, like a thousand iridescent light-needles, which then loses the head between two meanings. The blood rushed hotly through the arteries into the head, surging into the eyes. Beheading was now legally prescribed for executions, precisely because death is deemed to have another, conclusive quality in comparison to all other punishments. The death penalty is especially effective because it is irrevocable. The utter finality of the death penalty. When the guillotine came into use, this apparatus was considered to be certain. In the enthusiastic plea for an evenhanded cultivation of justice and for the sleeping animal—the larger heap of humanity. It was announced that the new and neatly-built guillotine was ready to be used. They are equipped with a relatively short steel panel which is firmly welded to the base and made out of rust-resistant metal. The crimes worthy of death, to which no petition for pardon was granted, were punished by it. The execution was therefore unjustified. Moreover, there were several condemnations to death and executions of other criminals. The number of executions was later limited mostly to the avengement of spectacular crimes. One who actually should have been in a situation to receive and to comprehend the message of the state ritual of execution. The ideal punishment of the regicide would consist of the sum of all possible tortures. Many see in the death penalty the culmination of superordinate justice which is embodied by the state. This was surely the reason for the utterly unsurpassably precise beheading. The list of crimes which can be punished by death is long. In order that the procedure is certain, it must be dependent on unchanging, mechanical means whose force and impact can be specified. The guillotine which finds utilization is the machine which corresponds to these principles. Death is reduced to a visible but instantaneous event. The delinquent is extinguished with no record. To feel pain, without emotion, to incline the head, as late as possible and then, when the expression of pain can no longer be held back, but not in order to conceal the face, but in order to have the head be hacked off by one of the assistants. The chest rises one final time, then it exhales and is dead. Which caught his blood in cloths at the beheading. Who displays the severed head, afterwards demonstrates where the face has come to a standstill. So that at the end no one would be there who could still be afraid of losing the world. It was only one more noise. That will have been taken care of. Now according to the law they are in charge and decide his fate. A medical discourse about the emotional state of a decapitated murderer, along with comments about the same; whether and to what extent it is the responsibility of a forensic doctor to diagnose a dubious mental framework. The spirit in the prison of an idea, numbed by its presence, unremittingly bent over by its weight. Condemned to death! So rise up! They carefully closed the lock, it was a machine on a machine, each syllable is like a part of the machine. Nothing in their demeanor gave an indication that they were about to pronounce a sentence of death. Two aspects seem to be important here: the first has the communicative action of the execution, action in the full sense of the word, and forms, establishes and institutionalizes into differentiating types of power. The power of the sovereign and of the modern disciplinary power. Parting of the hair. I am not angry at them for that reason. But at least the mind is not suffering, he is sleeping, he is as if dead. The three first holes are reserved for those condemned to death. No death is simple. No body dies. Above the heads could be seen a sort of stage made out of red wood, upon which three men were setting up a scaffolding. Not a glance in his eye. Are those not the same twitchings when the blood sprays drop after drop, or when the mind extinguishes one thought after another? When the eyes in their rotation are directed upward, then they will see only a darkly shadowed sky, and saw with deranged eyes, the pathway. The military tribunal read him the verdict, whereupon he sat down. Beheading became a collective, mechanically supported form of execution. Above

the heads could be seen a sort of stage made out of red wood, upon which three men were setting up a scaffolding. This was surely the reason for the utterly unsurpassably precise beheading. The list of crimes which can be punished by death is long. In order that the procedure is certain, it must be dependent on unchanging, mechanical means whose mechanical means whose force and impact can be specified. by death is long. In order that the procedure is certain. They carefully closed the lock, it was a machine on a machine, each syllable is like a part of the machine. Nothing in their demeanor gave an indication that they were about to pronounce a sentence of death. Two aspects seem to be important here: the first has the communicative action of the execution, action in the full sense of the word, and forms

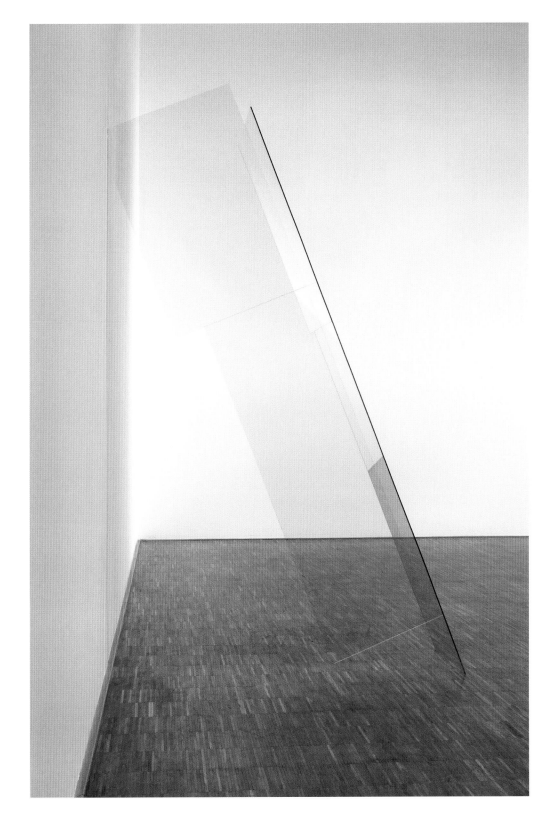

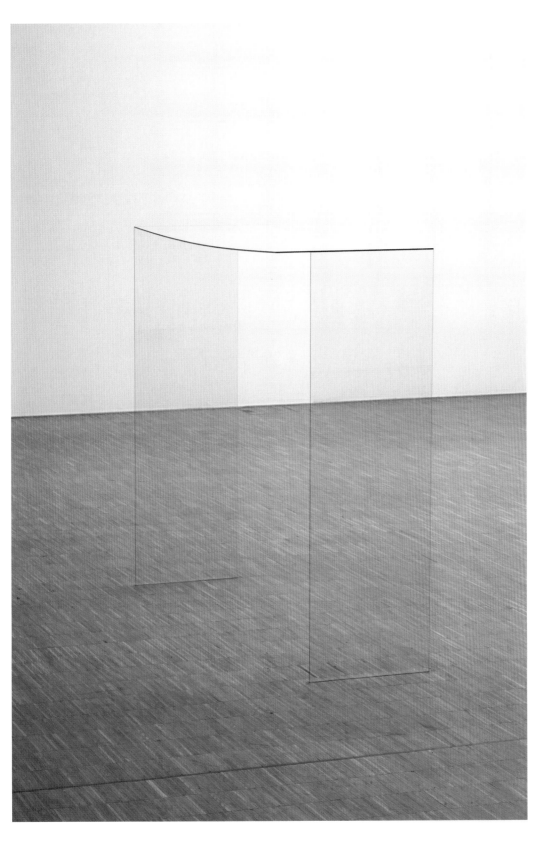

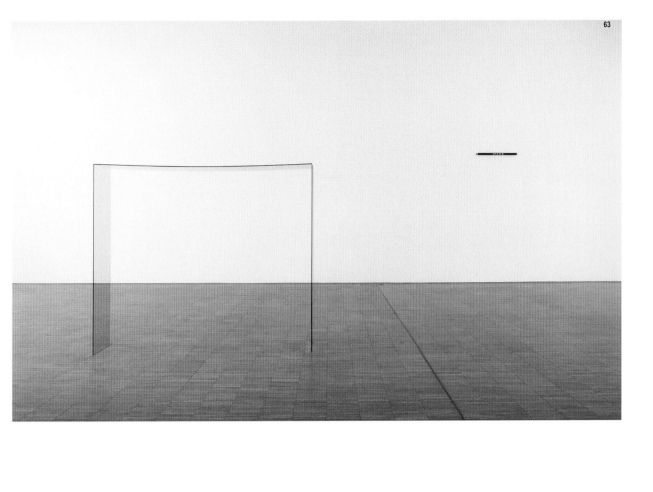

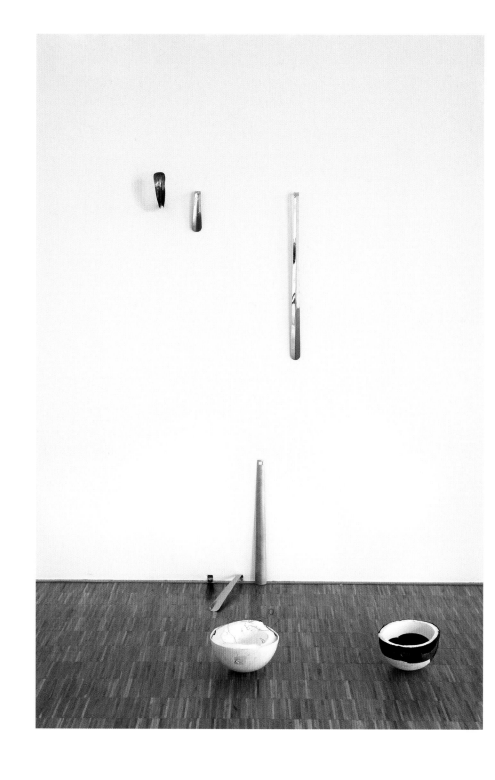

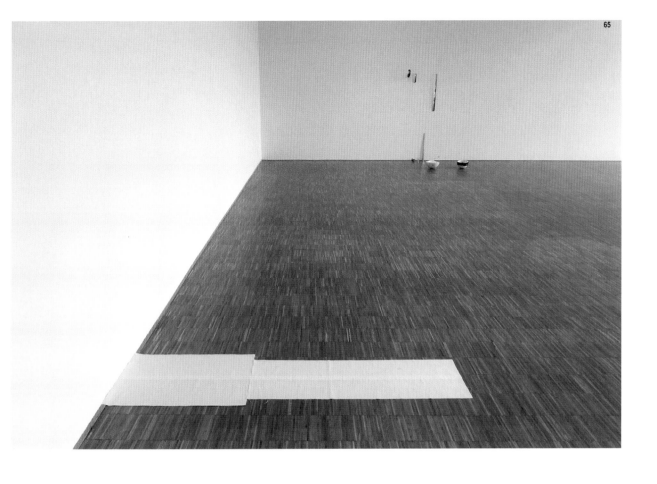

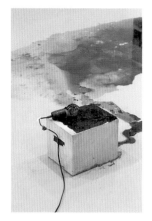

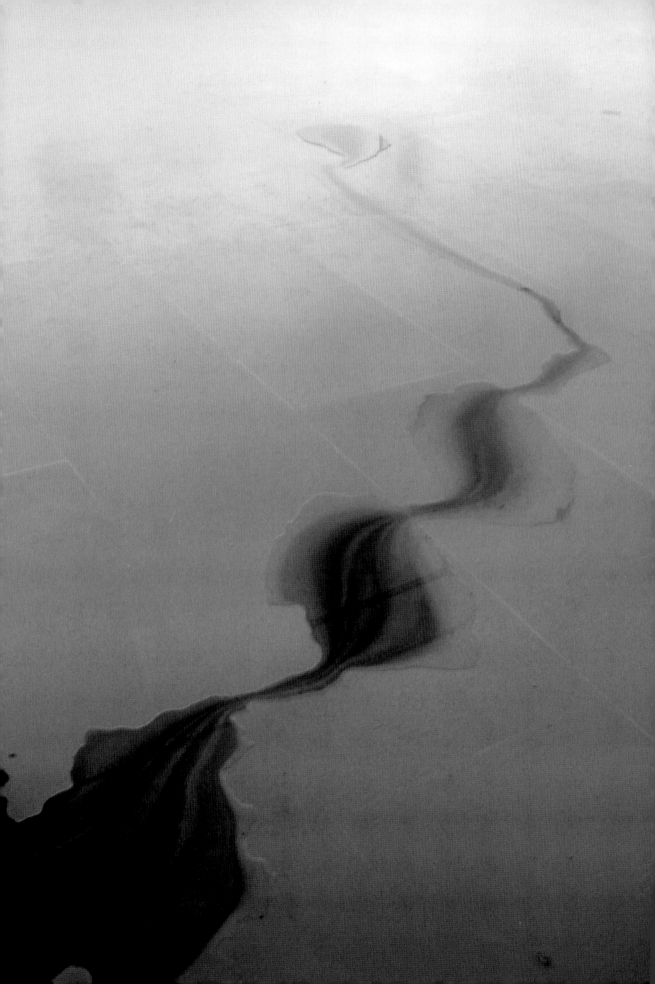

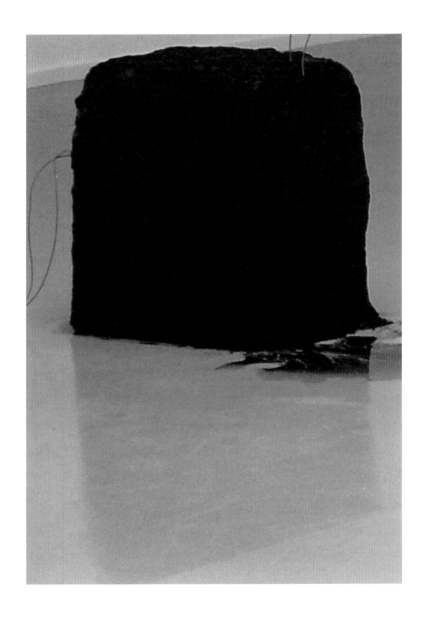

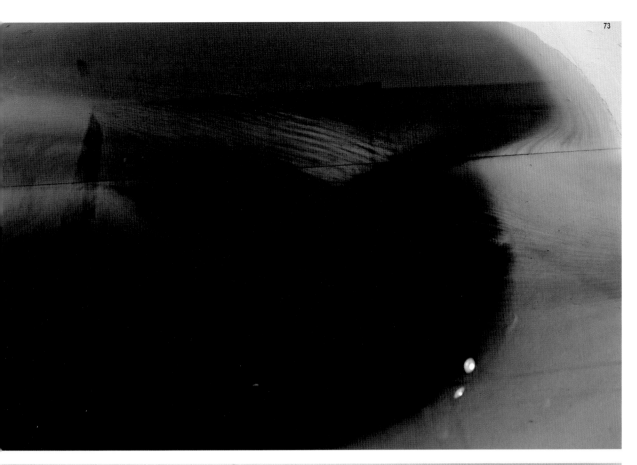

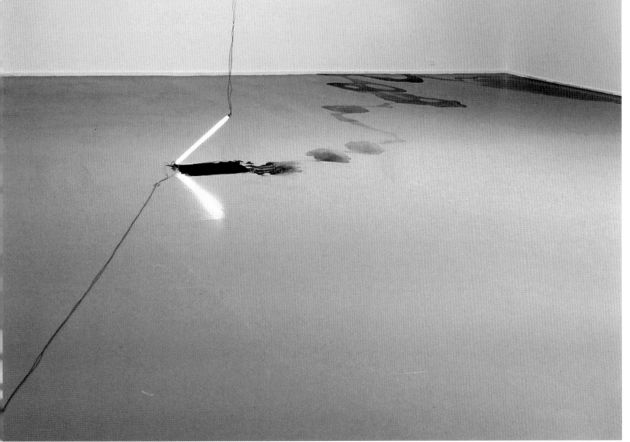

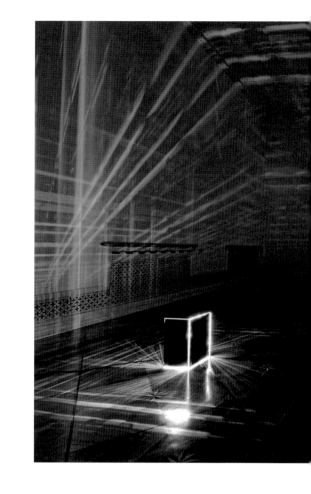

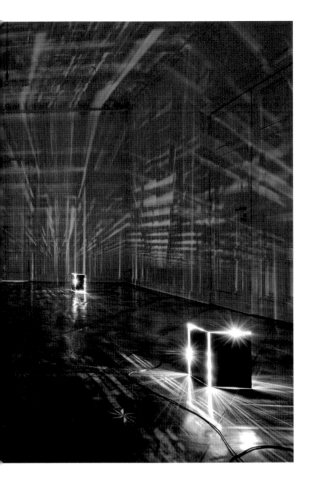

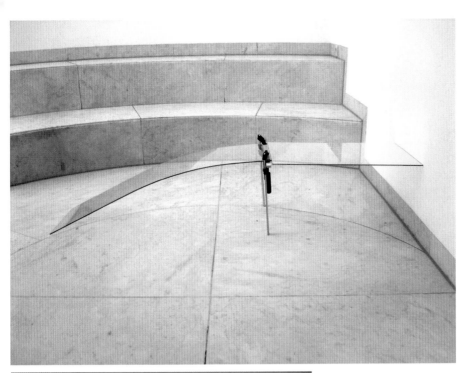

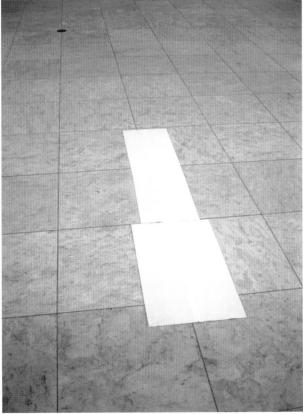

Verbotene Liebe

Liebe

 Verbotene

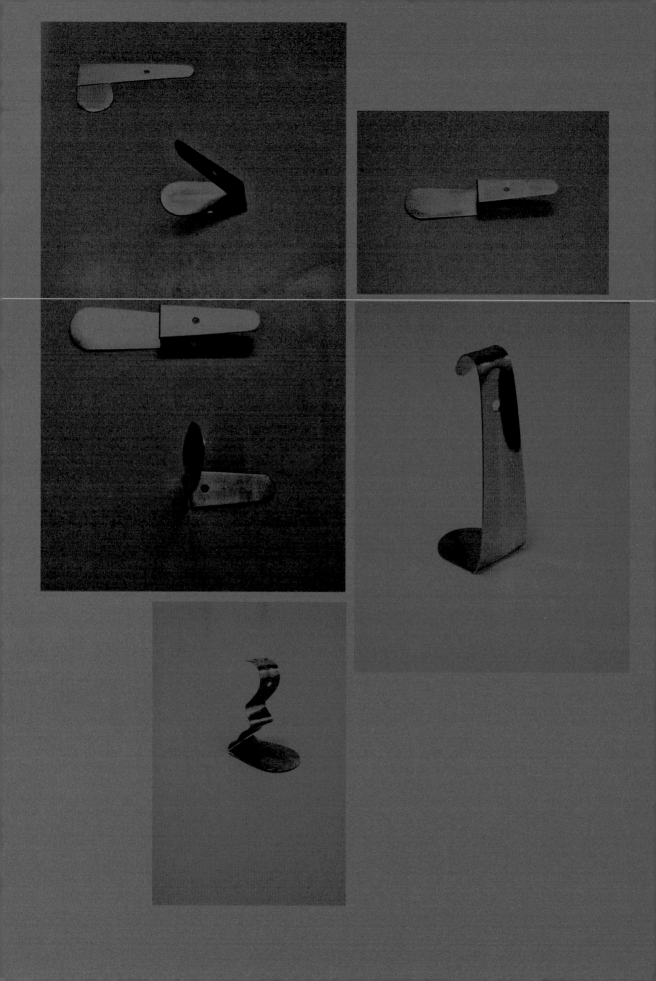

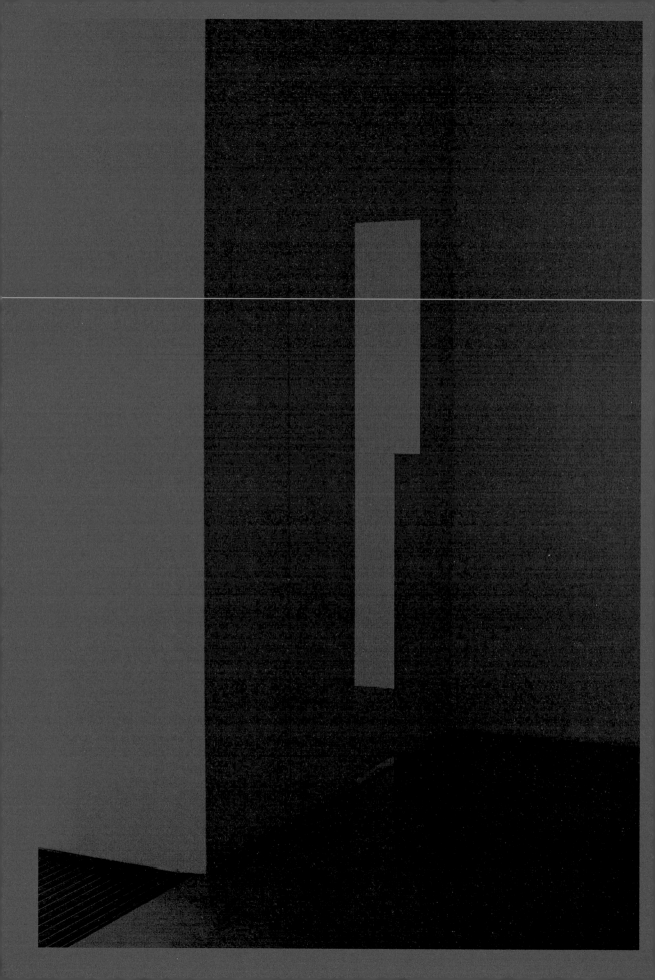

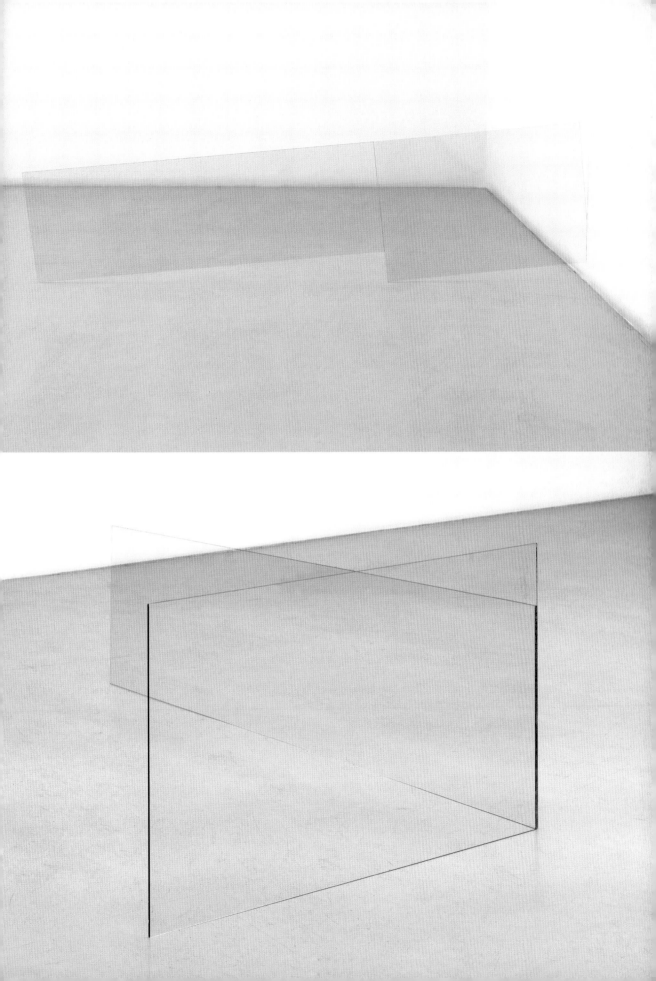

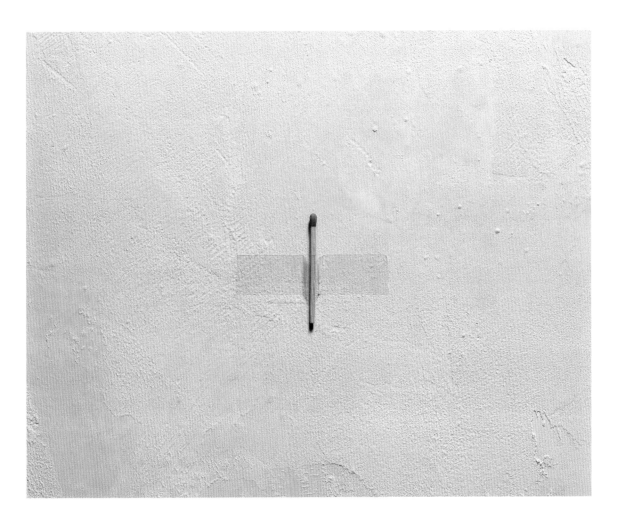

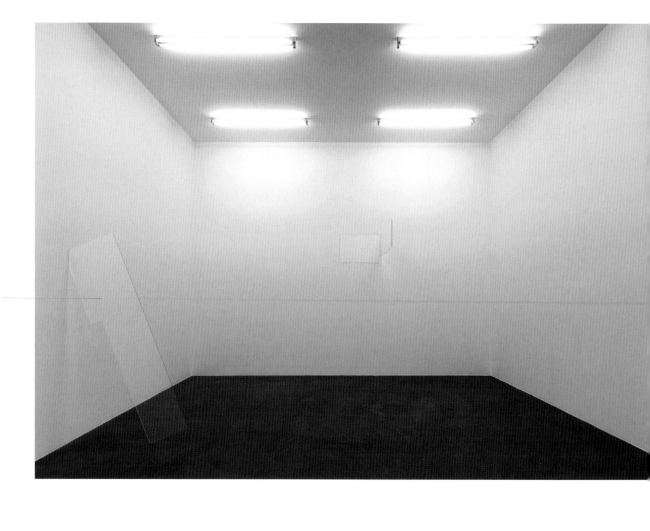

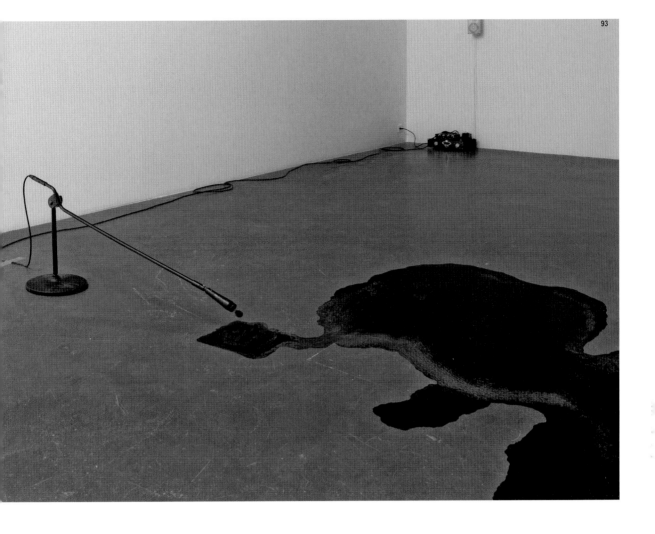

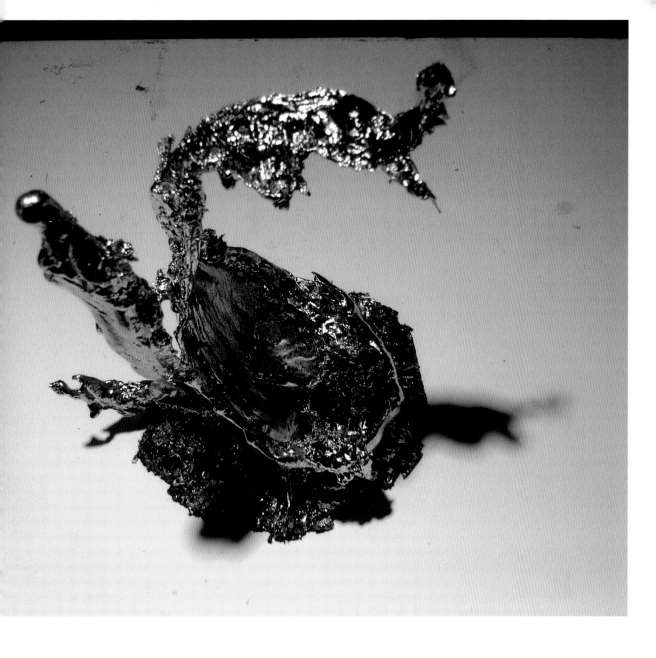

Cricothyroid
artery

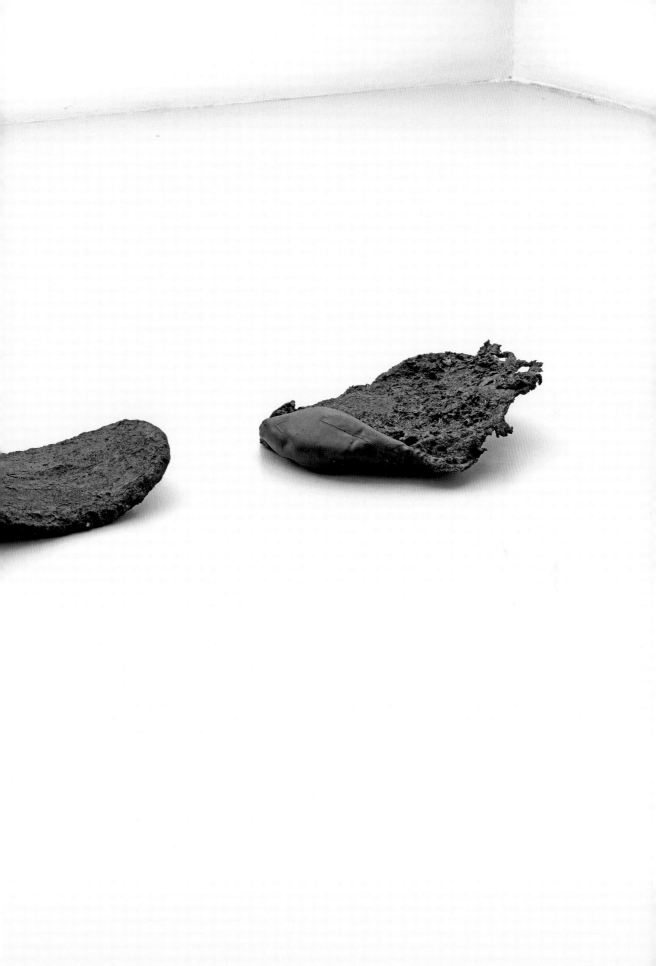

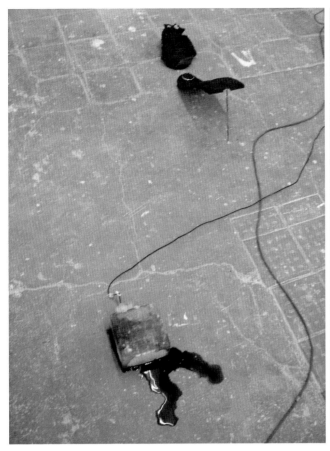

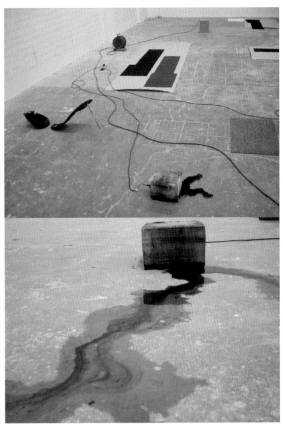

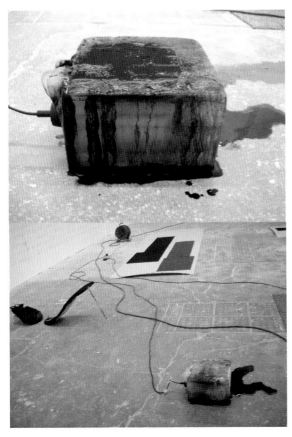

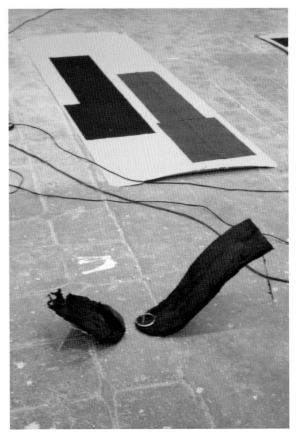

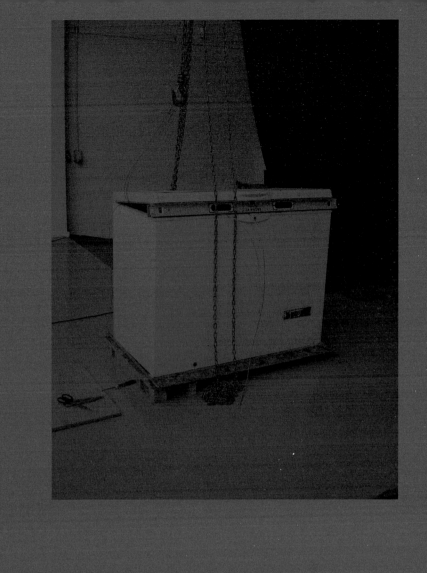

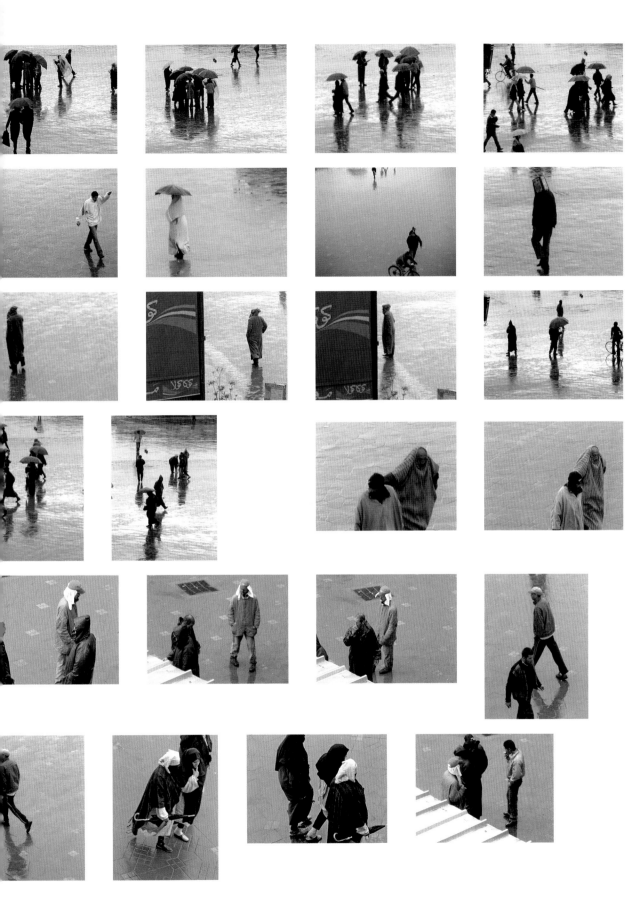

Ohne Titel (Spiegel-
lampe), 2007 / Untitled
(mirror lamp), 2007
4 Kuben aus Spiegeln,
60 / 100 W Glühlampen
/ 4 cubes made of
mirrors, 60 /
100 W light bulbs je
17 × 22 × 30 cm /
each 17 × 22 × 30 cm

37
Detail Eis, Tinte /
Detail: ice, ink

38 – 39
Installationsansicht,
Frieze Art Fair, 2006 /
Installation view, Frieze
Art Fair, 2006

Ohne Titel, 2006 /
Untitled, 2006
Eis, Lampe, Tinte,
Kreditkarte, Alufolie /
Ice, lamp, ink, credit
card, aluminium foil
Maße variabel /
Dimensions vary

40 – 41
Installationsansicht,
Frieze Art Fair, 2006 /
Installation view, Frieze
Art Fair, 2006

Ohne Titel, 2006 /
Untitled, 2006
Eis, Lampe, Tinte,
Kreditkarte, Alufolie /
Ice, lamp, ink, credit
card, aluminium foil
Maße variabel /
Dimensions vary

Ohne Titel, 2006 /
Untitled, 2006
Glas, Teer / Glass, tar
200 × 50 × 0,4 cm /
200 × 50 × 0.4 cm

43
Installationsansicht,
Frieze Art Fair, 2006 /
Installation view, Frieze
Art Fair, 2006

Ohne Titel, 2006 /
Untitled, 2006
Eis, Lampe, Tinte,
Kreditkarte, Alufolie /
Ice, lamp, ink, credit
card, aluminium foil
Maße variabel /
Dimensions vary

45
Installationsansicht,
Frieze Art Fair, 2006 /
Installation view, Frieze
Art Fair, 2006

Ohne Titel, 2006 /
Untitled, 2006
Eis, Lampe, Tinte /
Ice, lamp, ink
Maße variabel /
Dimensions vary

46 – 53
Dekaputkapitalisation,
2007 –

57
Ohne Titel, 2008 /
Untitled, 2008
Glas / Glass
200 × 50 × 0,4 cm /
200 × 50 × 0.4 cm

59
Ohne Titel, 2008 /
Untitled, 2008
Glas / Glass
125 × 39 × 0,4cm /
150 × 50 × 0,4 cm /
125 × 39 × 0.4cm /
150 × 50 × 0.4 cm

61
Ohne Titel, 2008 /
Untitled, 2008
Ikea Einkaufswagen-
stange, gelbes Klebe-
band / Ikea shopping
cart bar, yellow tape /
56 × 2,5 Ø cm / 56 ×
2.5 Ø cm

63
Installationsansicht,
Kunstverein Heilbronn,
2008 / Installation view,
Kunstverein Heilbronn,
2008

64
Ohne Titel, 2008 /
Untitled, 2008
6 Schuhlöffel (5 Chrom,
1 Messing) 2 Styropor-/
Plastikhelme, Draht,
Münzen / 6 shoe horns,
(5 chrome, 1 brass)
2 styrofoam / plastic
helmets, wire, coins
Maße variabel /
Dimensions vary

65
Installationsansicht,
Kunstverein Heilbronn,
2008 / Installation view,
Kunstverein Heilbronn,
2008

66
Installationsansicht
Open Space, Art
Cologne, 2008 / Installa-
tion view, Open Space,
Art Cologne, 2008

Ohne Titel, 2008 /
Untitled, 2008
Lampe, Eis, Tinte,
Betonsockel / Lamp, ice,
ink, concrete pedestal
Maße variabel, Sockel:
20 × 20 × 25 cm;
Lampe: 13 × 20 × 20 cm
/ Dimensions vary,
pedestal: 20 × 20 ×
25 cm; Lamp: 13 ×
20 × 20 cm

69
Detail einer Eislampe /
Detail of an ice lamp

71
Installationsansicht,
Allsopp Contemporary,
2007 / Installation view,
Allsopp Contemporary,
2007

Ohne Titel, 2007 /
Untitled, 2007
Neonröhre, Eis /
Wasser, Tinte, / Neon
tube, ice/water, ink
68 × 60 × 47 cm

73
Installationsansicht
Allsopp Contemporary,
2007 / Installation view,
Allsopp Contemporary,
2007

118

Flashanimation Still,
2004 / 2005 / Flash
animation still, 2004 /
2005

119

Ohne Titel, 2005 /
Untitled, 2005
Foto / Photograph
13 × 18 cm

120 – 121

Fotos, 2006 /
Photographs, 2006

122 – 124

Flashanimation Still,
2004 / 2005 / Flash
animation still, 2004 /
2005

127 – 131

Ohne Titel 2006 /
Untitled, 2006
Die Zeichnung geht
aus von einer fiktiven
Lichtstrahllinie, die an
den Wänden einer ge-
schlossenen Spiegelbox
gebrochen wird. Der
Reflexionswinkel ist der
rechte Winkel, so er-
reicht das Licht die Lam-
pe nicht. / The drawing
assumes a fictive line
of a beam of light which
is refracted at the walls
of a closed mirror box.
The reflection angle is
a right angle, thus the
light does not reach the
lamp.
Bleistift, Kugelschreiber
auf Papier / Pencil,

ballpen on paper
21 × 29,7 cm / 21 ×
29.7 cm

132

Foto / Photograph

133

Foto / Photograph

134

Foto / Photograph

135

Ohne Titel, 2004 /
Untitled, 2004
Fotografie (rip print) /
Photograph (rip print)
50 × 66 cm

136

Foto / Photograph

138 – 139

Ohne Titel, 2008 /
Untitled, 2008
Bleistift und Tinte auf
Papier / Pencil and ink
on paper
21 × 29,7 cm /
21 × 29.7 cm

GRUSSWORT

Kitty Kraus ist mit dem Kunstpreis blauorange 2008 der Deutschen Volksbanken und Raiffeisenbanken ausgezeichnet. In ihrer Preisträgerausstellung im Kunstverein Heilbronn Ende 2008 reichte das Spektrum von fragilen Glaskonstruktionen über Objektinstallationen bis zu Textarbeiten. Diese Arbeit setzt Kitty Kraus nun im vorliegenden Künstlerbuch – einem weiteren Bestandteil im Kontext der blauorange-Förderung – fort. Die 1976 in Heidelberg geborene und in Berlin lebende Künstlerin zeigt uns erneut beeindruckende Werke und Impressionen ihrer Arbeiten, die vielfach bisher noch nicht veröffentlicht wurden.

Der Kunstpreis blauorange ergänzt als bundesweites Engagement die zahlreichen regionalen und lokalen Initiativen der genossenschaftlichen Bankengruppe im Bereich Kunst und Kultur. Von Sozialreformern gegründet, fußt das Handeln und Wirtschaften der rund 1.200 Volksbanken und Raiffeisenbanken bis heute auf dem genossenschaftlichen Förderprinzip, der Hilfe zur Selbsthilfe, des bürgerschaftlichen Miteinanders. Mit den Kunstvereinen in Deutschland haben wir ideale Partner bei der Durchführung des Kunstpreises blauorange gefunden. Sie unterstützen junge Künstler, indem sie ihnen den so wichtigen Raum und die nötige Freiheit geben, ihre Werke zu präsentieren. Mein Dank gilt in diesem Zusammenhang den Juroren des Kunstpreises unter der Leitung von blauorange-Projektleiter Veit Loers. Der Jury 2008 gehörten sechs Vertreter von Kunstvereinen an: Marius Babias vom Neuen Berliner Kunstverein, Justin Hoffmann vom Kunstverein Wolfsburg, Matthia Löbke vom Kunstverein Heilbronn – zugleich Ausstellungspartner

des blauorange 2008 –, Kathleen Rahn vom Kunstverein Nürnberg, Christina Végh vom Bonner Kunstverein und Janneke de Vries von der Gesellschaft für Aktuelle Kunst in Bremen. Sie hatten aus 20 Empfehlungen von Professoren deutscher Kunstakademien eine Shortlist erstellt und daraus schließlich die Preisträgerin gewählt. Mit Kitty Kraus wurde eine Künstlerin ausgezeichnet, die nach den Worten der Jury weiß, wie man „Raum und Fläche in eine neue Spannung setzt, indem sie den Geheimnissen beider Dimensionen nachspürt".

Als Stifter wollen die Volksbanken und Raiffeisenbanken vielversprechende Künstler in der Verwirklichung ihrer Ziele und Antriebe fördern, mit den Mitteln, die sie für ihre Arbeit benötigen. Über das blauorange-Preisgeld in Höhe von 20.000 Euro hinaus erhalten die ausgezeichneten Künstler die Möglichkeit, ihre Werke in einer Einzelausstellung und einem Künstlerbuch zu präsentieren. Damit wollen wir junge talentierte Künstler in einer wichtigen Phase gezielt unterstützen. Es ist schön, schon jetzt beobachten zu können, dass Kitty Kraus die ihr zur Verfügung gestellten Mittel nicht nur intensiv nutzt, sondern ihren Erfolgsweg fortsetzt. Wir freuen uns sehr zu hören, dass das New Yorker Guggenheim Museum sie im Herbst 2009 zu einer Einzelausstellung eingeladen hat.

Es ist uns bewusst, dass die Idee des Künstlerbuchs – wie schon bei dem ersten Preisträger Danh Vo – ein gewagtes Experiment darstellt, das nicht jeden Kunstfreund ansprechen wird, da es nicht als repräsentative Publikation erscheint, sondern eng mit dem künstlerischen Prozess selbst verknüpft ist. Wenn man jedoch junge zeitgenössische Kunst in Deutschland fördern will, darf man ihr dort, wo es um künstlerische Ausdrucksmittel geht, keine Grenzen setzen. Jeder

Leser ist eingeladen, sich seine eigene
Meinung zu bilden.

Uwe Fröhlich,
Präsident des Bundesverbandes der
Deutschen Volksbanken und
Raiffeisenbanken (BVR)

GREETINGS

Kitty Kraus was the winner of the art prize blauorange 2008 of the German Cooperative Banks (Volksbanken and Raiffeisenbanken). At her prizewinner exhibition in Kunstverein Heilbronn in late 2008, the spectrum included fragile glass constructions, object installations, and textual works. Kitty Kraus continues this work in this artist book, a further component in the context of the blau-orange prize program. The artist, who was born in Heidelberg in 1976 and now lives in Berlin, again shows us impressive works in this publication, along with other aspects of her work never shown before.

As a nationwide program, the art prize blauorange supplements numerous regional and local initiatives undertaken by the German Cooperative Banks in the realm of art and culture. Originally founded by social reformers, Germany's ca. 1200 cooperative banks are still today based on the principle of cooperative funding, helping individuals to help themselves, and private commitment.

With the German Kunstvereine, we found ideal partners for carrying out the art prize blauorange. They support young artists by giving them the all-important space and the necessary freedom to present their works. My thanks to the jury of the art prize, directed by blauorange project leader Veit Loers. In 2008, the jury included six representatives from Kunstvereine: Marius Babias from Neuer Berliner Kunstverein, Justin Hoffmann from Kunstverein Wolfsburg, Matthia Löbke from Kunstverein Heilbronn (which was also the exhibition partner for blauorange 2008), Kathleen Rahn from Kunstverein Nürnberg, Christina Végh from Bonner Kunstverein and

Janneke de Vries from Gesellschaft für Aktuelle Kunst in Bremen. They selected a shortlist from among 20 suggestions submitted by professors from German art academies, and chose the prizewinner from this list. With Kitty Kraus, an artist was awarded who according to the words of the jury knows how "space and surface can be placed into a new tension with one another by pursuing the secrets of both dimensions."

As the prize benefactor, the German Cooperative Banks seek to promote promising artists in the realization of their goals and drive with the means they need to carry out their work. Alongside the blauorange prize money of 20,000 €, the award-winning artists are granted the possibility to present their work in a solo exhibition and in an artist book. With this, we want to support young talented artists in an important phase of their development. It is nice to see that Kitty Kraus placed the means provided to her to intensive use, but also continues in her success. We are pleased to hear, for example, that New York's Guggenheim Museum invited her to put on a solo exhibition in the fall of 2009.

We are aware that the idea of the artist book—as was already the case for the first prize winner Danh Vo—represents a daring experiment that might not appeal to all art aficionados, for it is not so much a representative publication, but rather is closely linked to the artistic process. But if we intend to support young contemporary art in Germany, we cannot set any bounds when it comes to artistic means of expression. We invite you to judge for yourselves.

Uwe Fröhlich,
President National Association of
German Cooperative Banks

GOLD AUS STROH

Veit Loers

Zwischen Bildhauerei und Malerei besteht ein kategorialer Unterschied. Die eine findet in der dritten Dimension statt, die andere in der zweiten. Die eine teilt die Beschaffenheit unseres Körpers, die andere bedarf der Übersetzung und Kodifizierung. Deshalb unterscheidet sich das phänomenologische Denken in die eine Kategorie hinein vom Denken in die andere völlig und wird nur im Begriff der Kunst egalisiert. Denn die Malschicht wird analog gelesen, während Materialien wie Eisen, Stahl, Holz, Bronze, Keramik und andere unmittelbar wirken.

Dieses Credo ist aber auch im Sinne der Avantgarde nutzbar: abstrakte Malerei und puristische Skulptur, also Sichtbarmachung der Fläche und Sichtbarmachung des Raums, gleichsam als Manifest. Vergessen sind die Zeiten, wo die Naturlastigkeit der Skulpturen nicht gefragt war, wo die Portalskulpturen der gotischen Kathedralen farbig gefasst waren oder die Holzskulpturen der Barockaltäre vergoldet. Das Missverständnis der Renaissance als eines Protoklassizismus lässt die Antike räumlich und monochrom auftreten wie die Bildgestalten Andrea Mantegnas. Daran knüpft die Moderne und auch noch die Minimal Art an. Natur wird sowohl in der Renaissance als auch beim Bauhaus in Relation zur Kultur gesetzt. „Die *Kunst* steckt in der Natur; wer sie *herausreißen* kann, der hat sie…", sagte Dürer, wobei er mit „herausreißen" möglicherweise etwas ganz anderes meinte, als man für gewöhnlich annimmt, nämlich das mittelhochdeutsche Wort für Herauszeichnen.[1] Wer also

die Natur von der dritten Dimension in die zweite übersetzt, der hat sie in der Kunst zur Verfügung.

Die Materialien in der Kunst können roh genossen werden, doch handelt es sich – im Sinne des berühmten Buches von Claude Lévi-Strauss – meist um gekochte Materialien (*Das Rohe und das Gekochte, 1971*). Die Werkstoffe wurden zivilisatorisch erst einmal zugänglich gemacht, also zubereitet und veredelt. Eisen ist gegossen, geschmiedet oder gewalzt, Holz gesägt oder geschnitzt, Glas geblasen oder gegossen, Keramik aufgebaut, gedreht oder gemodelt. Zuvor muss das Eisen verhüttet, das Holz geschlagen und gelagert, das Glas erzeugt und der Ton gesumpft und gebrannt werden. Zudem werden die Materialien gefeilt, glasiert, galvanisiert, poliert und geschliffen. Inzwischen ist auch die Palette der Werkstoffe wesentlich umfangreicher und vom Fertigungsprozess her komplizierter geworden, von Polyester bis zu Styropor. Und schließlich verwendet man Fertigprodukte als Materialien, also aus der Natur übernommene Objekte wie Steine und Eier sowie industriell angefertigte Produkte, Objets trouvées und Readymades. Am Ende sind Materialien wie Gold und Silber, Aluminium und Zink nicht mehr im Reich der Natur, sondern im Bereich der Kultur zu Hause, angefangen von ihrer materiellen bis zu ihrer sprachlichen Valorisierung; im Sinne der Alchemie sind sie also geläutert.

Kitty Kraus benutzt Fensterglas, Beton, Eisblöcke, elektrische Birnen, Anzugsstoffe und Griffe von Einkaufswagen. Bis jetzt. Es sind Produkte der Industrie, vorwiegend für den Hausbau, die Herrenbekleidung, den Konsum sowie für die Lebensmittel- und Getränkekonservierung (ehemals). Denn bevor Eisblöcke mittels Kühlaggregaten gefroren wurden,

schnitt man sie mit Sägen aus dem Eis zugefrorener Teiche. Auch wenn diese Materialien im Gewand zeitgenössischer Kunst auftreten, weisen sie zurück auf die Entstehung menschlicher Zivilisation, wie sie in den *Mythologica* von Levi-Strauss anhand der mythischen Erzählungen nord- und südamerikanischer Stämme beschrieben werden, die quasi noch in einer prähistorischen Verfassung lebten und leben.

In diesen Mythen geht es um Nahrungsmittel und die Form ihrer Beschaffung durch gute und böse Tiergeister. In den Geschichten wird ein komplexes mythologisches System mit Koordinaten aufgebaut, in dem Personen sowie Gegenstände des Alltags mit Wachstum und Tod in Verbindung gebracht werden. Die Materialien sind solche des Sammelns und der Jagd. In Europa muss man analog meist verlorengegangene Mythen, wie sie in den Märchen anklingen, in die Bronzezeit verlagern, da Edelmetalle dabei eine große Rolle spielen. Im *Rumpelstilzchen* der Brüder Grimm soll die Müllerstochter aus Stroh Gold spinnen, und sie tut dies mit Hilfe eines Naturdämons namens Rumpelstilzchen, der dafür das spätere Erstgeborene des zur Königin avancierten Mädchens erhalten soll (als Menschenopfer). *Schneewittchen*, ein anders gelagerter Fall, überlebt in einem hochartifiziellen Glassarg den ihr von bösen Mächten (in diesem Falle der Königin) zugedachten Tod. In einem anderen Märchen rettet das *Blaue Licht* einer Hexe mit seinen Wundereigenschaften den alten, in den Brunnen gefallenen Soldaten. Die kulturellen Qualitäten der Wunderstoffe sind dialektisch mit guten und bösen Naturgeistern vernetzt. Die einen belohnen redliche Menschen damit, die anderen locken damit, um Macht über die Menschen zu erlangen oder wollen die Werkstoffe an sich reißen. Bei

allem Geheimnis, das über den Stoffen liegt, geht es um Tausch. Das kostbare Material aus Geisterhand ist schon zivilisatorisch aufbereitet, bevor es magisch wirksam werden kann. Mit List versuchen sowohl Menschen als auch Dämonen sich der Werte zu versichern.

Aber die eigentliche Metamorphose der Stoffe liegt darin, wie handwerkliche, manufakturelle und industrielle Erzeugnisse aus dem Dreidimensionalen ins Zweidimensionale überführt werden. Sie sind in der Skulptur wie in den Raum gezeichnet, Abbildungen, die sich im Raum ausstülpen. Deshalb sagte man im Deutschen früher auch „Bildwerke" dazu. Ihre bildhafte Qualität bewirkt aber noch etwas anderes, das nämlich, was in den Mythen und Märchen anklingt. Das Gold, das nach Verlassen von *Frau Holles* Anwesen auf Marie fällt, und sogar das Zuckerwerk und die Lebkuchenziegel des Hexenhäuschens aus *Hänsel und Gretel* werden als Werterzeugnisse mit Aura angereichert. Sie verwandeln sich, und das ist das Merkwürdige daran, in paradiesische Naturprodukte zurück. Martin Heidegger hat in seinem bekannten Aufsatz vom „Ursprung des Kunstwerks" anhand von Vincent van Goghs *Schuhen* den Unterschied von Zeug (Erzeugnis), Ding und Kunstwerk herausgearbeitet. Das Zeug „verschwindet in der Dienlichkeit". „In der Kunst hingegen werden die Stoffe nicht verbraucht", sagt Heidegger, „sondern zum Leuchten gebracht."[2]

Kitty Kraus wendet im Gespräch ein, es ginge ihr gar nicht um die Materialien, sie würde lieber unsichtbare oder stofflose Skulpturen machen, wenn dies möglich wäre. Im heideggerschen Sinne arbeitet sie also am „Umriss" ihrer Werke, dem Reissen in Dürers Vorstellung. Es scheint sich Heideggers Frage aufzutun:

„Sobald wir es auf dergleichen am Werk
absehen, haben wir unversehens das Werk
als ein Zeug genommen, dem wir außer-
dem noch einen Oberbau zubilligen, der
das Künstlerische enthalten soll. Aber das
Werk ist kein Zeug, das außerdem noch
mit einem ästhetischen Wert ausgestattet
ist, der daran haftet."[3]

Als Bild kann sich das, was man Skulp-
tur nennt, jenen Status erhalten, der in
den Koordinaten der Werterelation des
Märchens zum Vorschein kommt, als
Inbild des Ringens zwischen guten und
bösen Mächten. Und nur als Bild gelingt
ihm der Spagat, die glänzende Seite der
industriellen Fertigung der Natur künst-
lerischer Arbeit zuzuführen.

[1] Vgl. in diesem Sinne auch Martin Heidegger,
Der Ursprung des Kunstwerkes, in: Holzwege,
Frankfurt am Main, 1952, S. 58

[2] Ibid.

[3] Op.cit., S. 28

GOLD SPUN FROM STRAW

Veit Loers

There is a categorical difference between sculpture and painting. While one takes place in the third dimension, the other takes place in the second. One shares the make up of our body, while the other requires translation and codification. This is why phenomenological thought in the one category is totally distinct from thinking in the other, and only becomes comparable in the concept of art. For the painterly layer is read analogically, while materials like iron, steel, wood, bronze, ceramics, and others have a direct impact.

But this creed can also be used in an avant-garde sense: abstract painting and purist sculpture, making the surface visible, making the space visible as a manifesto, as it were. Forgotten are the times where the naturalistic element of sculpture was unwanted, as the portal sculptures of Gothic cathedrals were colored or the wood sculptures of the Baroque altars were gilded. The misunderstanding of the Renaissance as a protoclassicism allows antiquity to appear spatial and monochromatic, like the figures of Andrea Mantegna. This is the starting point for modernism and minimal art. Nature is set in relation to culture in the Renaissance as well as the Bauhaus. "Art is in nature; whoever can tear it out (*herausreißen*), has it," as Dürer put it: but by using the word *herausreißen* he might have meant something quite different than we usually think, that is, the Middle High German word for *herauszeichen*, the drawing of individual elements of a picture.[1]

Whoever translates nature from the third dimension to the second has access to it in art.

Materials in art can be enjoyed raw, but usually it is "cooked" material, in the sense of the famous book by Claude Lévi-Strauss (The Raw and the Cooked, 1964). The materials were first made accessible by civilization, that is, prepared and refined. Iron is cast, forged, or milled, wood is cut or carved, glass is blown, or poured, ceramics are created, spun, or modeled. Iron first has to be mined, the wood felled and stored, glass has to be made, and clay watered and burned. In addition, the materials are filed, glazed, galvanized, polished, and ground. In the meantime, the palette of materials has become much more extensive and more complicated in terms of manufacturing processes, from polyester to Styrofoam. And finally, finished products are used as material, objects taken from nature like stones or eggs as well as industrially manufactured products, found objects, and readymades. In the end, materials like gold and silver, aluminum and zinc are no longer at home in the realm of nature, but in the realm of culture, from their material to their linguistic valorization: in an alchemistic sense, they are refined.

Kitty Kraus uses window glass, concrete, ice blocks, electric light bulbs, suit fabric, and the handles of shopping carts. Until now. They are products of industry, usually from construction, men's clothing, or consumer products, as well as conservation of food and drink. For before ice blocks were frozen using electric refrigeration, they were cut from the ice of frozen lakes. Even when these materials appear in the garb of contemporary art, they refer back to the emergence of human civilization, as described in Levi-Strauss' *Mythologica* using the mythical

narratives of the North and South American tribes, who lived and live in a quasi-prehistorical state.

These myths are about food and the form of its procurement by good and evil animal spirits. In these stories, a complex mythological system is constructed with coordinates in which persons as well as objects of everyday life are linked to growth and death. The materials are those of collecting and the hunt. In Europe, usually lost myths, as they sound in the fairy tales, need to be placed in the Bronze Age, for precious metals play an important role here. In "Rumpelstilzchen" by the Brothers Grimm, the miller's daughter makes gold from straw with the help of a natural demon named Rumpelstilzchen, who is to receive the later first born of the girl, once she has become queen, as a human sacrifice. "Snow White," a differently structured case, survives the death intended for her by evil forces (in this case, the queen) in a highly artificial glass coffin.

In a different tale, the "Blue Light," the blue light of a witch saves a soldier who has fallen into a well with its miraculous qualities. The cultural qualities of the magical materials are dialectically networked with good and evil natural spirits. Some award the honest, while others use them as bait to achieve power over people or seek to seize the material for themselves. Despite all the secrets that are placed on the materials, it is about exchange: the precious material from a spirit's hand is already civilizationally prepared before it can become magical. Human beings and demons alike try to secure precious objects by way of cunning.

But the actual metamorphosis of the materials lies inheres in how products of craftsmanship, manufacture, or industrial production are taken from the three-dimensional to the two-dimensional. They are marked in the sculpture as in space. Illustrations that are turned inside out in space. This is why they were once called *Bildwerke* in German, literally "picture works." Their pictorial quality, however, also causes something else, which resonates in the myths and fairy tales. In the story "Mother Hulda," the gold that falls to Marie after leaving Mother Hulda's home, and even the sugar and gingerbread of the witch's house in "Hansel and Gretel" are enriched with aura as valued products. They transform—and that is the strange thing about them—back into paradisiacal natural products. In his well-known essay on the "Origin of the Work of Art," Heidegger distilled the difference between product, thing, and the work of art using Vincent van Gogh's *Shoes*. The product "disappears in usefulness." "In art, in contrast, the materials are not used," according to Heidegger, "but brought to glow." [2]

In conversation, Kitty Kraus argues that for her it is not at all about materials, she would rather make invisible or matter-less sculptures, if this were possible. In the Heideggerian sense, she works on the outlines of her works, the "tearing" in Dürer's notion. Heidegger's question seems to arise: "As soon as we intend to use the work in this way, we have also taken the work as a product that we attribute an superstructure that is supposed to contain the artistic. But the work is not a product also outfitted with an aesthetic value that adheres to it." [3]

As an image, what we call sculpture can take on the status that appears in the coordinates of the value relation in the fairy tale as the epitome of the struggle between good and evil forces.

And only as image is it able to lead the shiny side of industrial production to the nature of artistic work.

[1] See Martin Heidegger, "Der Ursprung des Kunstwerkes," in: Holzwege (Frankfurt am Main, 1952), p. 58

[2] Ibid.

[3] Op.cit., p. 28

FORMEN UND KRÄFTE

Bettina Klein

Glastränen *(Batavische Tropfen), in eine lange Spitze auslaufende Glastropfen, welche man durch Eintropfen von geschmolzenem Glas in kaltes Wasser erhält. Durch die plötzliche Abkühlung wird das Glas sehr spröde, und sobald man die äußere Spitze abbricht, zerspringt das ganze Gebilde mit großer Gewalt und zerfällt zu Staub.*

Meyersches Konversations-Lexikon, Fünfte Auflage, Leipzig und Wien, 1894

Ist die Oberfläche einer solchen Glasträne intakt, kann man sie offenbar selbst mit einem Hammer nicht zerschlagen. Erst deren Verletzung setzt die große Spannung innerhalb des fragil erscheinenden und doch sehr belastbaren Gebildes frei. Glas ist im physikalischen Sinne eine zähe Flüssigkeit, eine unterkühlte Schmelze, bei der die Kristallisation so langsam vonstatten geht, dass sie nie zu Ende geführt wird.

Kitty Kraus arbeitet seit einigen Jahren mit Glas, in seiner vielleicht unspektakulärsten Erscheinungsform: Rechteckig zugeschnittene Scheiben aus Fensterglas sind das Material für ihre fast unsichtbaren Skulpturen. Nur die scharfen, ungeschliffenen Kanten der Glasscheiben zeichnen den Umriss einfacher geometrischer Konstruktionen. Was in der fotografischen Abbildung als zartes, minimalistisches Objekt erscheint, hat in seiner physischen Präsenz im Raum ein bedrohliches Potential. Die Schärfe der Schnittkanten, die Härte und Kälte der Oberflächen und das prekäre Gleichgewicht der Scheiben sind förmlich körperlich spürbar – ragen sie zum Beispiel aus der Wand, denkt man unwillkürlich an ein Fallbeil. Mitunter stehen sie unter hoher Spannung und biegen sich bis zu ihrer Sollbruchstelle. Die Einbeziehung des Betrachters erfolgt bei diesen Arbeiten zum einen über seine Einbildungskraft (die *Phantasia*), die über die reine Wahrnehmung hinausgehende Auseinandersetzung mit dem Objekt. Zum anderen, auf der unmittelbar visuellen Ebene, über die partielle und verzerrte Spiegelung seines Körpers in den gläsernen Oberflächen, die eben nicht nur eine abstrakte Konstruktion, sondern (unter anderem über die Assoziation mit menschlichen Figuren) ein echtes Gegenüber darstellen.

Spiegelungen sind seit den Anfängen der Fotografie eine verbreitete Strategie, um über einen Illusionsraum die Dreidimensionalität in das von seinem Wesen her zweidimensionale Medium zu übertragen. Für die Titelseite dieses Katalogs wurde eine Kupferplatte fotografiert. Der Illusionsraum strebt hierbei gegen Null. Nur minimale Indizien, kleine Lichtreflexe, Kratzer, Oxidationsspuren verweisen auf die Materialität des „leeren" Motivs. Dieses Cover, Abbildung von etwas quasi nicht Repräsentierbarem, leitet programmatisch den folgenden Inhalt ein. Unter anderem wird es um Licht und Spiegelung (aus Kupfer wurden die ersten Spiegel hergestellt), physikalische Kräfte (es ist ein sehr guter Stromleiter) und das Potential von Materialien als Träger von Ideen gehen.

Kennt man Kitty Kraus' Arbeit aus ihren Ausstellungen, in denen fotografische Beiträge, wenn überhaupt, nur eine marginale Rolle spielen, wird man sich vielleicht über die große Präsenz von Fotografien in dieser Publikation wundern. Neben den üblichen Installationsfotos professioneller Ausstellungsfotografen und eigenen, beim Aufbau oder im Ate-

lier aufgenommenen Schnappschüssen der Künstlerin ist hier eine Reihe von Referenzbildern verschiedenen Ursprungs versammelt. Diese fotografischen Notizen können, betrachtet man sie in ihrer Gesamtheit, einen wesentlichen Schlüssel zum Werk liefern: aus dem Flugzeug fotografierte Landschaften, deren Relief durch die große Entfernung verflacht, eine Nahaufnahme der Fontäne eines Springbrunnens bei Nacht, das Stencil einer Feder auf einem Oberarm, Sprünge in einer Glasplatte, eine durch Strudel bewegte Wasseroberfläche… Es sind Transformationsprozesse von einem Aggregatzustand zum anderen, Übergänge von Makro- und Mikrokosmen, Organischem und Anorganischem, Natürlichem und Künstlichem.

Vergleichbare, jedoch in den Kunstraum übertragene Prozesse zeigen auch die Ausstellungsfotografien. Manche Arbeiten, wie die in verschiedenen Varianten realisierten Eislampen, schreiben sich den jeweiligen Ausstellungsräumen regelrecht ein; das schmelzende, schwarz gefärbte Eis folgt kleinsten Neigungen im Fußboden, füllt Risse im Beton und trocknet schließlich zu einer im jeweiligen Raum individuellen Zeichnung.[1] Bei einem linearen Prozess wie diesem würde es sich anbieten, ihn durch eine chronologische Abfolge von Fotografien zu dokumentieren, die fast nahtlos die einzelnen Stadien des Objekts zeigen könnten. Doch die Fotografie wird hier nicht primär als vermittelndes Medium für ephemere Prozesse im Sinne einer möglichst objektiven Darstellung eingesetzt – eine seit der Aktions- und Konzeptkunst der 60er Jahre übliche Praxis –, vielmehr geht es um Verrätselung: Die Detailaufnahmen etwa zeigen die konkreten Abläufe nicht deutlicher, sondern fördern durch die Fokussierung eine kontemplative Sichtweise. Wir sehen nur Zustände, Mo-

mentaufnahmen aus der kurzen Existenz dieser Objekte: den Augenblick, in dem die Oberfläche des schwarzen Eisblocks ganz weiß wird, weil er sich abrupt der neuen Umgebungstemperatur anpassen muss, das Leuchten der Glühbirne im Inneren des nunmehr an einen dunklen Glasbaustein erinnernden Kubus oder die langsam entstehende Pfütze aus Wasser und Tinte, die in der Nahsicht einem Flußdelta aus Vogelperspektive gleicht. Die vordergründig spektakuläre Schönheit dieser sich selbst generierenden Zeichnung täuscht zunächst vielleicht über die melancholische Grundstimmung der „schwarzen Galle" hinweg, die sich als letzter Atem des Objekts am Boden ausbreitet.

Der Eisblock in der Kunsthalle Zürich barg ein Mikrofon, das über einen Verstärker die durch den Temperaturschock und die so entstehende Spannung ausgelösten knackenden Geräusche aus dem Inneren des Objekts in den Raum vermittelte. Die Soundanlage blieb bis zuletzt eingeschaltet, und das weiterhin Geräusche abtastende Mikrofon verstärkte gewissermaßen nur noch die Stille im Raum: Die am Boden getrocknete Tinte wirkte gegen Ende der Ausstellung wie ein ausgesprochener, erschöpfter Satz (S. 93).

Formale, bewusst zwanghafte Strenge, aber auch deren Auflösung und/oder Zerstörung kennzeichnen die meisten Arbeiten, sei es das durch Spiegelung *gebrochene* Licht[2], die zerspringenden Kuben der Spiegellampen oder die durch normierte Schnitte in eine einheitliche Form gebrachten, doch an den Rändern offenen Anzugstoffe.

Die Haltung bleibt so lange gewahrt, bis eine destruktive, mitunter auch befreiende Kraft – meist sind es durch elektri-

schen Strom erzeugte Hitze oder mechanische Manipulationen – auf sie einwirkt. So wurden etwa Standardschuhlöffel für eine Edition rechtwinklig verbogen, abgesägt, flachgewalzt… Diese durchdeklinierte Form erscheint in der fotografischen Abbildung (S. 86) stilistisch den Sachfotografien am Bauhaus verwandt. Durch ihren lakonischen Witz und vor allem durch die Gegenüberstellung mit einem Computerausdruck, auf dem die Tinte aquarellartig zerfließt (hier sind es Bilder von „Einstiegshilfen", die man im Netz finden kann), wird dieser erste Eindruck aber schnell relativiert.

Bei der Installation aus Schuhlöffeln und Schutzhelmen in der Heilbronner Ausstellung (S. 64) steht das Fragmentarische und Zeichenhafte der einzelnen Komponenten im Vordergrund. Die metallisch glänzenden, neuen Schuhlöffel aus Chrom – Variationen einer industriell gefertigten Grundform – nehmen wie beiläufig stehende oder hängende Positionen an Wand und Boden ein. Ein einzelner, abgenutzter Schuhlöffel aus Messing biegt sich provozierend wie eine herausgestreckte Zunge nach oben. Am Boden liegen, Opferschalen gleich, zwei aufgeschnittene Schutzhelme, in die ein paar Münzen geworfen wurden. Oder haben wir es bei den Helmen doch eher mit „um eine Kopfbreite gekürzten" Schädeln zu tun, die eine Verbindung zum Enthauptungstext[3] im ersten Ausstellungsraum herstellen?

Dieser aus etlichen Fragmenten gestückelte Text versucht der unfassbaren Endgültigkeit der Geste des Enthauptens auf den Grund zu gehen, indem er Passagen aus im Internet gefundenen historischen und modernen Texten seziert und zu einer schwer erträglichen Dichte bringt. Das allmähliche Auslaufen des gedruckten Textes impliziert ein offenes Ende, bzw. eine ewige Fortführung.

[1] Hierbei fällt ins Auge, wie sehr sich die Architektur dieser Räume, obwohl meist minimalistisch und dem Ideal des White Cube sehr nahe kommend, in den Vordergrund drängt. Fensterrahmen, Deckengestaltungen, die Beschaffenheit der Fußböden haben plötzlich eine enorme optische Präsenz und werden als „zuviel" empfunden.

[2] Die nach innen gewendeten Spiegel der Lampen schließen die Bildwelt aus; das gespiegelte „Nichts" wird durch den Lichtstrahl repräsentiert und der so entstehende unendliche Raum nach außen projiziert.

[3] Der Text war in der Ausstellung im Kunstverein Heilbronn als Vorabdruck der Broschüre zur Ausstellung von Kitty Kraus in der Kunsthalle Zürich zu sehen. Für dieses Buch wurde die Arbeit am Text fortgeführt (vgl. S. 46-49).

SHAPES AND FORCES

Bettina Klein

*Prince Rupert's Drops (Batavian tears),
glass drops with a long tip created by drip-
ping molten glass into cold water. Due to the
sudden cooling, the glass becomes very tough
and brittle, and as soon as the outer tip is
broken, the entire formation explodes with
great force and disintegrates.*

Meyersches Konversations-Lexikon,
Fifth Edition, Leipzig and Vienna, 1894

If the surface of a glass tear remains in-
tact, it cannot be destroyed even with a
hammer. Only the breaking of the surface
releases the great tension within the frag-
ile appearing and yet very resilient struc-
ture. In a physical sense, glass is a liquid,
an undercooled molten mass where the
crystallization is so slow that it is never
completed.

Kitty Kraus has been working with glass
for several years in perhaps its most
unspectacular mode of appearance: rect-
angular panes of window glass are the
material used for her almost invisible
sculptures. Only the sharp, unpolished
edges of the glass panes mark the outlines
of simple geometric constructions.
What appears to be a delicate minimal-
istic object in photographs has a threat-
ening potential in its physical presence
in space. The sharpness of the edges, the
hardness and cold of the surfaces and the
precarious balance of the panes are for-
mally physically palpable—sticking out of
the wall, for example, they automatically
make us think of a guillotine. Sometimes
they are under strong tension, and bend
toward their predetermined breaking
point. On the one hand, the inclusion of

the beholder takes place in these works
through the imagination, *phantasia*, an
engagement with the object that goes
beyond mere perception. On the other
hand, on a directly visual level, through
the partial and distorted reflection of
the beholder's body in the glass surfaces,
which is not just an abstract construction
but represents an actual counterpart (by
way of association with human figures).

Since the beginnings of photography,
reflections have been a widespread strat-
egy for transferring three-dimensionality
through an illusory space into the inher-
ently two-dimensional medium. For the
cover of this catalog, a copper plate was
photographed. The illusory space here
moves toward nothing. Only minimal
indications, small reflections of light,
scratches, traces of oxidation point to
the materiality of the "empty" motif.
This cover, the illustration of something
almost not representable, serves as a pro-
grammatic introduction to the content
that follows. This will be about, among
other things, light and reflection (cop-
per was used to make the first mirrors),
physical forces (copper is a very good
conductor of electricity) and the potential
of materials to communicate ideas.

Those familiar with Kitty Kraus' work
from her exhibitions, where photographic
contributions only play a marginal role,
if at all, will perhaps be surprised at the
large presence of photography in this
publication. Alongside the usual installa-
tion photographs by professional exhibi-
tion photographers and her own snap-
shots, taken in the process of setting up
the works or in the studio, a series of ref-
erential images of various origins are as-
sembled. These photographic notes could,
if seen as a whole, provide an essential
key to the work: landscapes taken from
the airplane, whose relief is flattened by

the great distance, a close up of a fountain at night, a stencil of a feather on an upper arm, cracks in a glass plate, a water surface moved by a eddy. They are transformation processes from one aggregate state to others, transitions of macrocosmos and microcosmos, the organic and the inorganic, the natural and artificial.

Comparable processes, yet transferred to the art space, are shown in the exhibition photographs. Some works, like the ice lamps made in several variants, are veritably inscribed in the respective exhibition spaces: the melting, black-dyed ice follows the tiniest declines in the floor, fills cracks in the concrete and ultimately dries to a drawing in the respective space.[1] It would seem appropriate to document a linear process like this with a chronological series of photographs that could almost show the individual states of the object. But photography here is not primarily used to communicate ephemeral processes in the sense of a possible objective representation, a practice common since action and conceptual art of the 1960s. It is rather about mystification: the detail shots, for example, do not show the concrete processes any more clearly, but promote a contemplative point of view by way of their focus. We only see states, snapshots of the brief existence of these objects: the moment in which the surfaces of the black ice block become entirely white, because it suddenly has to adjust to the new surrounding temperature, the illumination of the light bulb inside the cube, now reminiscent of a glass brick, or the slowly emerging puddle of water and ink, that in close up seems like a river delta from a bird's eye view. The superficial spectacular beauty of this self-generating drawing distracts us form the basic melancholic mood of the "black gall" that spreads out on the floor as the object's last breath.

The ice block at Kunsthalle Zürich contained a microphone that by way of an amplifier communicated the noises caused by the emerging tension inside the object to the outside space. The sound system was turned on until the end, and the microphone, which continued to pick up sound, only transferred silence to the space. At the end of the exhibition, the ink dried on the floor seemed like an uttered, exhausted sentence. (p. 93)

Her work is usually marked by a formal, consciously obsessive stringency, but also its dissolution and/or destruction, be it a light refracted by reflection,[2] the exploding cubes of mirror lamps, or the suit fabrics normed by their cuts, open at the edges. This attitude is maintained until a destructive, even liberating force—usually heat generated with electricity, or mechanical manipulations—has an impact. Standard shoehorns, for example, were bent for an edition, sawn off, flattened… This thoroughly conjugated form in the photographs (p. 86) seems stylistically related to photography from the Bauhaus. With their laconic humor and especially their presence alongside a computer print out, where the ink blurs like a watercolor (here they are images of "boarding aids" that can be found in the Internet) this first impression is soon relativized.

In the installation of shoehorns and protective helmets in the Heilbronn exhibition (p. 64), the fragmentary and symbolic quality of the individual components stands at the foreground. The metallically shining, new chrome shoehorns—variants of an industrially produced basic form— take standing or hanging positions on the wall or floor, as if by accident. A single, used brass shoehorn bends provocatively like a tongue stuck out. Lying on the floor, like two ceremonial bowls, are two protective helmets cut open, with a cou-

ple of coins thrown into them. Or are the
helmets in fact skulls "cut down the width
of a head," creating a link to the decapi-
tation text in the first exhibition space?[3]
This text, pieced together from several
fragments, tries to get to the bottom of
the inconceivable finality of the gesture of
decapitation, by dissecting passages from
historical and modern texts found on
the Internet and bringing them together
in a density that is difficult to bear. The
printed text gradually runs out, implying
an open end, or an eternal continuation.

[1] Here it is apparent how much the architecture
of these spaces, although usually minimalistic and
close to the ideal of the white cube, comes to the
foreground. Window frames, ceilings, the material
of the flooring suddenly all have an enormous op-
tical presence, and seem to be "too much."

[2] The mirrors turned inward in the lamps exclude
the visual world: the mirrored "nothing" is repre-
sented by a light beam, and the endless space cre-
ated in this way is projected outward.

[3] This text could be seen at the exhibition in Kun-
stverein Heilbronn as an advance copy of the bro-
chure for the Kitty Kraus exhibition at Kunsthalle
Zürich. The work on this text was continued for
this book (see pp. 50-54).

SPLITTER UND SCHERBEN

Matthia Löbke

Die Arbeit *Ohne Titel, 2008* von Kitty Kraus konfrontiert uns durch drei einfache, jeweils 3 bis 4 mm dicke Glasscheiben, die wie ein Tisch aus zwei versetzten 30 cm breiten und 120 cm hohen Seitenteilen und einem 150 mal 50 cm messenden, aufgesetzten Oberteil ausgeführt sind, mit so schwerwiegenden Fragen wie der nach dem, was die Welt im Innersten zusammenhält.

Peter Fischli und David Weiss gaben ihrer Fotoserie absurder Objektkonstellationen den Titel: *Am Schönsten ist das Gleichgewicht kurz bevor es zusammenbricht!* Deren dadaistische Vorgehensweise wie ihr vermeintlich duchampscher Objektwitz lässt sich nicht mit der Strenge und gleichzeitig der Erklärungsnot vergleichen, die uns bei eben jenem speziellen Objekt von Kitty Kraus begegnen. Vielmehr geht von diesem Objekt eine dominante, beinah bedrohliche Präsenz aus.

Der Glaser, der beim Aufbau der Arbeit in Heilbronn mitgearbeitet hat, hielt das Objekt nicht für möglich, ging davon aus, dass aufgrund der Spannung die obere Platte zerreißen würde. Die Besucher der Ausstellung meinten, sie müssten die Luft anhalten. Ich war jeden Morgen, wenn ich die Türe zu unserem großen Saal öffnete, gespannt, ob die drei Glasscheiben noch stehen und bemühte mich, jeden Lufthauch und vielleicht auch lautes Türeschlagen zu vermeiden. Die Sorge, das Objekt könnte zerspringen und im schlimmsten Fall noch Anwesende durch splitterndes Glas verletzen, war stets präsent. Warum eigentlich? Die Arbeit war gut im Boden verankert, die obere Platte mit den Seitenteilen verklebt.

Ist das ähnlich wie bei den großen, begehbaren Stahlskulpturen von Richard Serra? Sie vermitteln durch bedrohlich wirkende Neigungen das Gefühl großer materieller Präsenz, mit der immer wieder auch das Gleichgewicht thematisiert wird.

Kitty Kraus arbeitet mit verschiedenen Materialien. Sie hat für die beschriebene Arbeit bewusst das Material Glas gewählt. Es erfüllt die gewünschten Eigenschaften, führt es doch den Blick auf den Punkt des Zerspringens, demonstriert den Verlust des Gleichgewichts.

Deutlicher wird dieses Vorgehen noch durch die immer wieder thematisierte Verbindung ihrer Arbeiten zur menschlichen Gestalt. Es scheint, als würden zwei Menschen, den Rumpf gebeugt, Kopf an Kopf aneinandergelehnt stehen. Das Kräftemessen bekommt einen menschlichen Charakter, es ist absurd und zerbrechlich.

Kitty Kraus zwingt den Betrachter durch diese Wahrnehmung der Zerstörung des Gleichgewichts also dazu, über die Rätselhaftigkeit der Welt nachzudenken, über die Diskrepanz zwischen sicht- und fühlbarer Materialität und der steten Präsenz einer möglichen Veränderung des Materials durch seine Zerstörung. Betrachtet man ihr Objekt nämlich als Versuchsanordnung, als ein Werkzeug zur (Selbst-)Vergewisserung von Realität, stößt man an deren Grenzen und ist auf die eigene Kenntnis der den Dingen innewohnenden Statik angewiesen, das heißt ihr Potenzial an Unerklärbarem, und so wie man mitunter nichts finden kann, was dem eigenen Leben so ganz

eigentlich einen objektiven Sinn verleiht,
ist es auch mit diesem Objekt: Man kann
es staunend betrachten, kann es lieben
oder auch nicht, wartet aber doch darauf,
ob es zusammenbricht.

SPLINTERS AND FRAGMENTS

Matthia Löbke

Through three simple planes of glass, each three to four millimeters thick, that are made like a table of two staggered side elements, three centimeters wide and 120 centimeters high, and a top 150 by 50 centimeters in size, *Untitled* (2008) by Kitty Kraus confronts us with questions as profound as the question of what holds the world together at its innermost.

Peter Fischli and David Weiss gave their photographic series of absurd object installations absurd titles: *Am Schönsten ist das Gleichgewicht kurz bevor es zusammenbricht!* (Balance is Loveliest Just Before It Collapses). Their Dadaistic way of proceeding as well as their supposedly Duchampian humor with the object cannot be compared with the strictness and need of explanation that we are confronted with in this special object by Kitty Krauss. The object rather exudes a dominant, almost threatening presence. The glazier who helped in the installation of the work in Heilbronn thought the object was impossible, and thought that the upper pane would break under the tension. Visitors to the exhibition thought they had to hold their breath. Each morning, when I opened the door to our large hall, I was very curious to see whether the three glass panes were still standing, and tried to avoid the slightest breeze or the slam of a door. There was a constant worry that the object could explode, and in the worst-case scenario injure those still present. But why? The work was well anchored in the floor, the upper pane glued to the side elements.

Is the same true of Richard Serra's large steel sculptures, which can also be entered by the beholder? In their threatening seeming inclines, they communicate the feeling of large material presence, also repeatedly addressing the question of balance.

Kitty Kraus works with various materials. She consciously chose glass as a material for the work described. It fulfills the desired properties, bringing our gaze to focus on the point of disintegration, demonstrating the loss of balance.

This approach becomes even more evident by way of the recurrent link of her works to the human figure. It seems as if two people with their torsos bent forward were standing head to head. The struggle between forces takes on a human character; it is absurd and fragile.

Through this perception of the destruction of balance, Kitty Kraus forces us to think about the puzzling character of the world, the discrepancy between sight and palpable materiality and the constant presence of a possible change in the material through its destruction. Looking at the object as an experimental arrangement, a tool for assuring (ourselves) about reality, we arrive at the limit, and are forced to rely on our own awareness of the statics inherent in things, that is, their potential in terms of the inexplicable, how it is impossible to find something to lend our own life an objective meaning: this is also the case with this object, one can look at in amazement, love it or not, but await its collapse.